The Art of Sketching

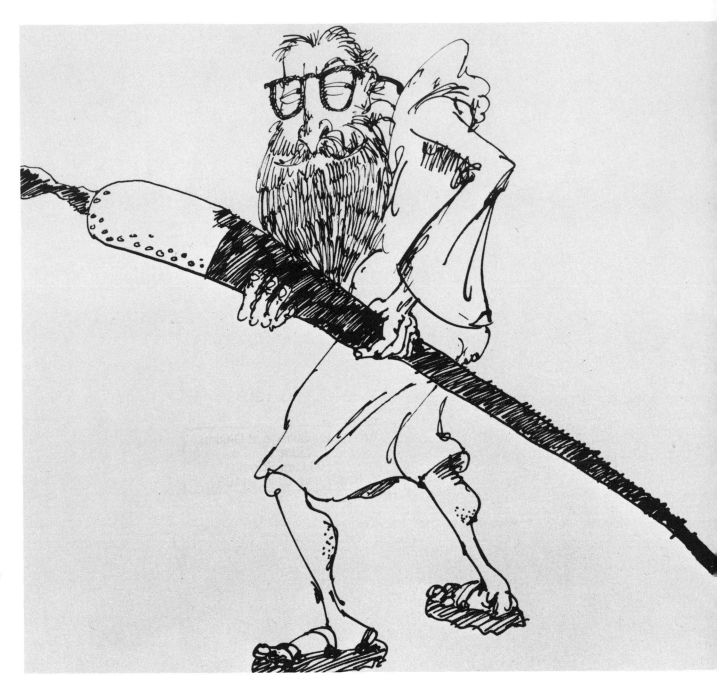

Pen and ink sketch by Kevin Burton.

The Art of Sketching

Albert W. Porter
Professor of Art, California State University
Fullerton, California

Davis Publications, Inc.
Worcester, Massachusetts U.S.A.

Printed in the United States of America
Library of Congress Card Number: 77-78826
ISBN 0-87192-092-1

Printing: Halliday Lithograph Corporation
Binding: Halliday Lithograph Corporation
Type: Helvetica by Davis Press
Graphic Design: Penny Darras
Consulting Editors: Gerald F. Brommer and George F. Horn

10 9 8 7 6 5 4 3 2 1

*To Joe Mugnaini whose art and teaching have been
a constant inspiration.*

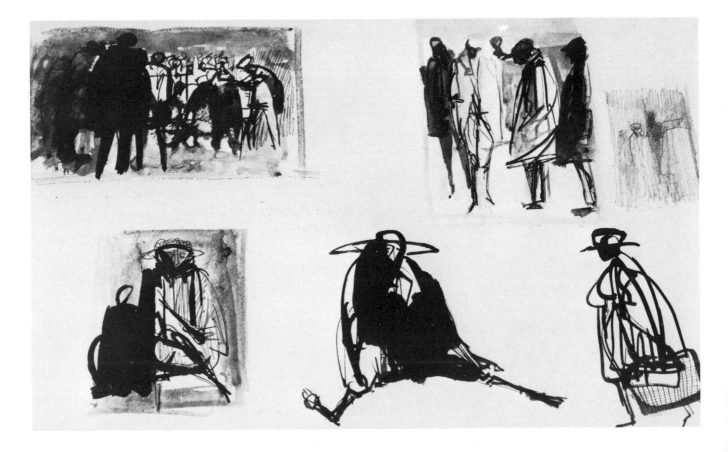

Contents

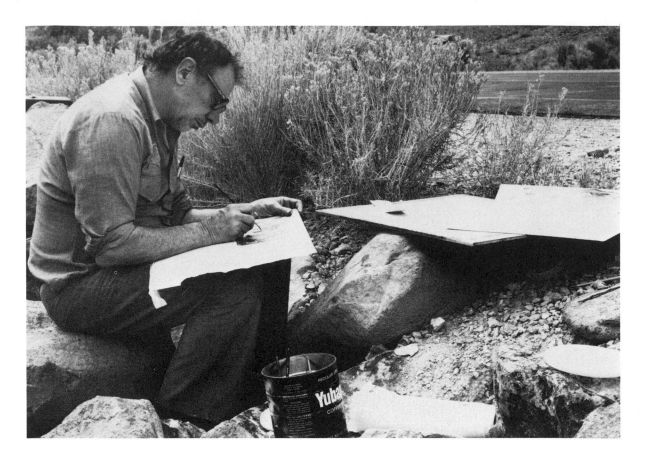

Sketching trips are important to artist Joe Mugnaini for garnering fresh landscape ideas. Utah provides the inspiration.

University art student, Tom Wright, makes numerous studies of the visual environment at Newport Beach, California.

Gayle Marie Pajaud, age five, is starting a sketching habit that already has expressive potential.

Introduction

The art of sketching is one of the most fundamental skills an artist possesses. It matters little whether the artist considers painting, graphic design, crafts, or sculpture his or her specialized avenue of visual expression. The ability to sketch is an integral part of the artist's wide range of talents.

The Sketching Habit

Artists sketch for a variety of reasons. Sometimes they doodle playfully with lines and forms without an apparent direction in mind. But, in general, their main thrust is to get at essentials. Quick, instinctive reaction with a drawing implement is one means of capturing a thought or idea, or the essence of fleeting subject matter. The artist can pounce on illusive subjects by rapidly making notations that record important information. Since we live in a world of constant visual impressions and changing images, the artist must react quickly and reflexively to these mutations. A sharp sketcher can put down his thoughts and impressions with enviable ease. His skills are primarily developed by assiduous practice. He is basically good because he constantly sketches. It is a habit pattern, one each of us should develop and finally become gloriously addicted to. Habits make most activities easier because we do them without too much thought or effort. Our actions become natural and automatic.

Along with the skill that sketching entails, is the more important aspect of expressing ideas with conviction and vigor. Drawing facility permits ideas to flow, giving our intuitive and imaginative senses a chance to be fully energized. The combination of sketching facility and imaginative application affords us the full potential for producing work that is visually exciting and aesthetically satisfying. Since an artist must express his inner feelings about the ideas or subject matter he uses, it is important that he generate visual images that reflect the message he wants to communicate. The sketch can help him deliver this visual punch. The use of bold line can register the force of a form, while delicate rhythmical lines can express the lyrical aspects of nature. The sketching process involves observation, feeling and interpretation. We must train our vision and our intuitive sensibilities.

Once we get the "faith," so to speak, then we can develop a new artistic life style. Instead of avoiding drawing, we welcome it; and like all good things we never get enough of it. It is a positive addiction! We will find chronic sketchers always carrying around either a sketchbook or some form of paper to mark on. The long waits at restaurants, bus, train and plane terminals, plus those lost moments when waiting for friends to arrive, become productive escapes into a sketchbook. Curiously, when habits are indulged, they get stronger. Hence, we must select good ones. The sketching habit may not guarantee

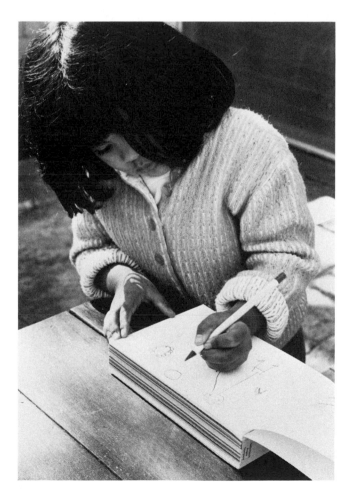

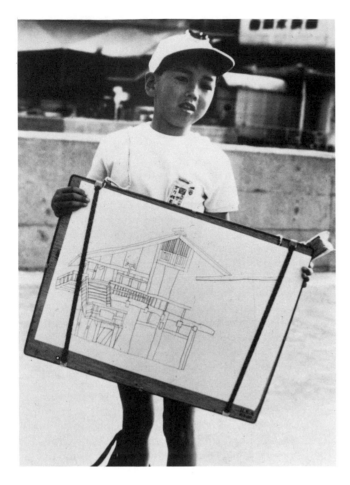

A very competent sketch is evolving from the hands of this Japanese youngster. Sketching your local environment helps to match your sketching skills with visual impressions.

It is amazing how incisive the line quality is in this study of a bird. It was drawn with comparative ease by Gayle Marie Pajaud, age five.

Artist Gerald Brommer is a skillful and creative watercolorist who employs his sketchbook to record a wide variety of outdoor locations around the world. This kind of sketching provides both information and inspiration for future paintings.

artistic excellence, but it is one sure-fire method for putting us on the right track to graphic competence.

It is hard to think of one significant artist who did not draw either well or on a continuous basis. The sketching habit is one we as artists or students need to engage in, and secure as a life style.

Improving Drawing Skills

As youngsters we were delighted to pick up a box of crayons or some pencils and test out a wide array of subjects ranging from humorously distorted drawings of our parents to rockets taking off to the moon. The whole world seemed to open up in a visual sense through the lines, shapes, and colors we enthusiastically applied to paper. This sketching skill might have been considered a natural ability that everyone seemed to possess to some degree. Moreover, drawing and sketching were fun.

We should revive this early enthusiasm for sketching. Learning to draw or to improve our drawing skills is within the realm of everyone who desires to develop this important ability. Success may be solely measured by the degree of satisfaction we receive from our efforts. A sketchbook is an inviting arena for putting down all kinds of visual impressions dealing with our outside and inner worlds.

The main thing is to start, to begin wherever our skills are, and to conceive of this process as an extension of what we see and interpret or of what we may imagine. When we involve ourselves in learning to observe carefully, to record that observation, then our sketches reflect that new perception. Since "practice makes perfect," we need to program time for sketching that ensures a degree of success. Even twenty to thirty minutes a day will sharpen our senses, and when this time is extended the results are even more promising.

One may start on simple subjects, such as still life shapes or uncomplicated plant forms, and gradually move into more complex and challenging subjects. As skill and confidence grow, you will get the urge to explore creatively, and to test drawing skills with a variety of inventive applications.

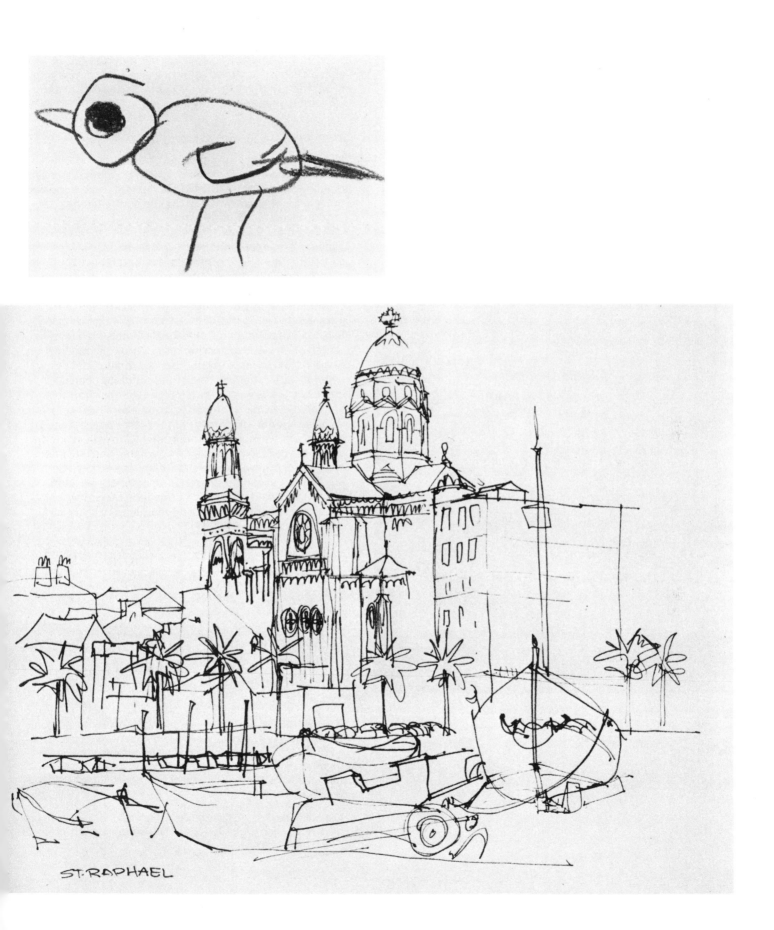

ST·RAPHAEL

With strong drawing abilities, it is much easier to engage in more involved art processes, such as painting, illustration, and design, as well as in those areas dealing with three-dimensional forms.

Sketching—A Springboard to Ideas

The best dividend that sketching offers is its ability to produce ideas. A quick thumbnail sketch may end up as a building, some drawn lines could generate a composition put into paint, or an investigation through sketches may produce a new sculptural form.

Sketching is a creative thought process for artists. It allows one to experiment with a wide range of ideas in a short time span. Furthermore, since the creative thought process is constantly fluctuating on and off, the sketch pad can be a great monitor for those moments when the on switch is activated. This same switch also can be triggered by going through a series of sketches that lead to a positive connection. One idea produced by a drawn sketch often leads to another either through modification or alteration. In some mysterious fashion our ideas flow when we allow them to. Sketching seems to open up the channels. Since each drawn image requires short time spans, we are able to search in diverse directions.

It is important to remember that ideas are fleeting. To retain them, we must note them down. The writer scribbles notes, the composer heads for the piano, and the artist reaches for his sketchbook. Once an idea is down on paper it can be dealt with, modified, refined—or even discarded. A sketchbook is a great repository of visual ideas that either lies fallow or generates a new life in completed works.

When designing jewelry, we may begin by working directly with metal, wood, or precious stones. More likely, we will create a sketch before starting the finished piece. Designs can be composed in minutes, and a series of alternative solutions can be rapidly noted, giving the artist numerous visual answers on which to base a final selection. Joe Gatto uses an incisive sketching technique to come up with a wide range of ideas for rings and pendants. The finalized neckpiece, which takes numerous hours of crafted skill to complete, is based on sketches which are accomplished in minutes.

necklace

front piece

amulets
seed
from

perforations

11

Ways to Sketch

The ability to put down the essences of forms with a minimum of line is a talent worth developing. This skill undoubtedly evolves from many years of serious drawing involvement, but it can be considered even in our initial efforts in sketching.

Simple Line Drawings

Simple line drawings require perceptive vision, and often a spontaneous drawing response. Learning to observe the essential major forms and structure of the subject gives us the important clues as to the kind of descriptive line to be used. We should train ourselves to visually judge sizes, weights, and the characteristic qualities of the subject. How tall or wide or curvilineal is the form? Are there major directional thrusts that convey the movement of the form? The resultant line we use will reflect these visual judgments. If we see or remember a form as light or delicate, then the line we will use will be a thin, graceful one which reflects these properties. Certainly, a heavy line captures the aspects of bulk, weight, or power of a form. Even when we draw forms from memory, our line interpretations can sense those qualities we feel are important.

Practicing with different weights of line and variety within a single line helps to make our lines more sensitive and interpretive. Simple pressure changes with a drawing implement give line interest and expressiveness. Also, the speed of the line conveys certain characteristics of forms. Eventually, a rhythmical drawing pattern will develop that combines visual judgment, line speed, pressure changes, and personal reactions to our subjects.

Studying the work of such masters of line as Matisse, Picasso, Ingres, Dufy, Rodin, and Leonardo Da Vinci provides additional inspiration and points the way to effective solutions by simple line expressions.

Sam Clayberger captures the bulk, weight, and somewhat dejected appearance of one feminine form with a weighty loose line and freely treated mass. The contrasting graceful head study uses line that describes structure and the rhythmic flow of hair.

Maximizing the sweep of a brush line, Bill Pajaud has quickly executed a descriptive simplification of a frog.

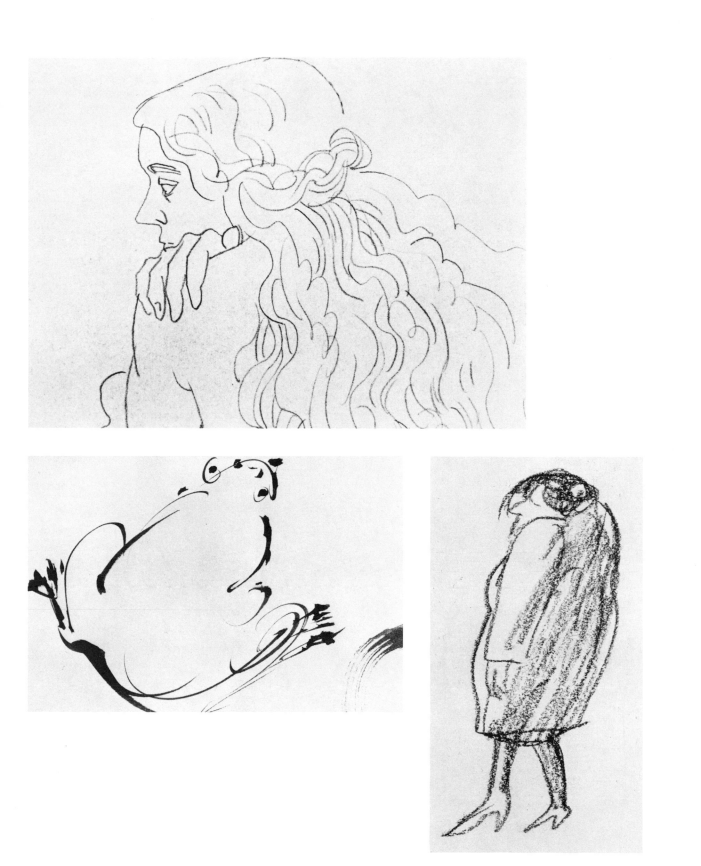

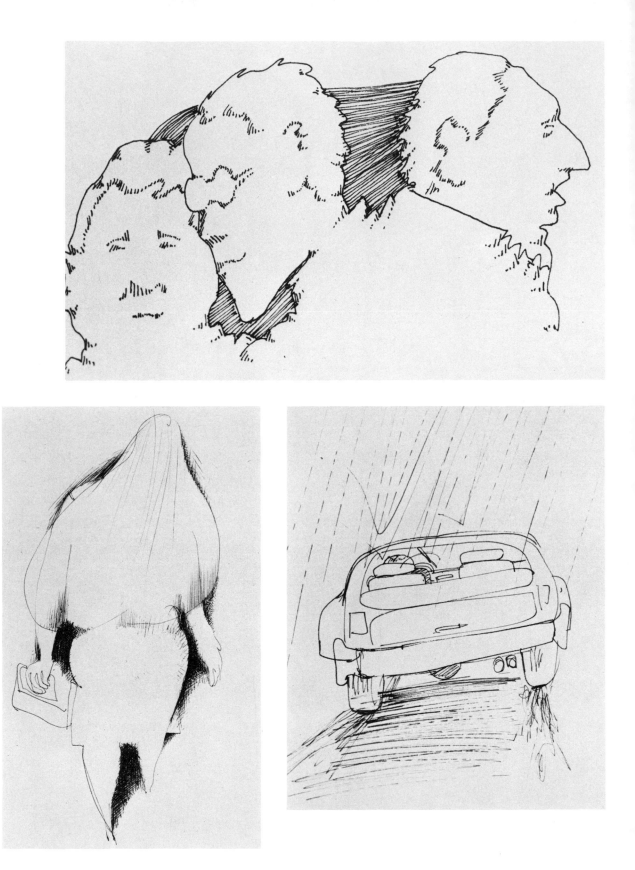

Kevin Burton combines simple continuous and broken lines to describe and link three heads. Massing of line in between heads gives contrast and added interest.

Bill Pajaud complements a minimum of line with small areas of cross-hatched darks to reinforce the outer edge of his figure sketch.

A few lines may capture a remembered moment as in this experience driving in the rain. Line has been pulled rapidly across the paper to achieve the feeling of pelting rain and a slick road surface.

Swinging a line through or around an area of a form can capture the essential structure. This lineal back study stresses the twists and turns of the pelvic and thoracic areas of the body.

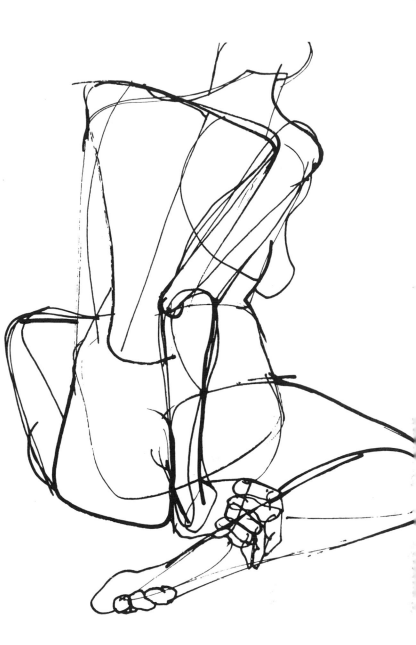

Contour Studies—Concentrated Seeing

One effective way to increase our drawing ability is to take the time to observe in a concentrated fashion objects and forms around us. By looking slowly and carefully at the construction of many diverse forms, we will develop both a knowledge of the construction of forms and a sensitivity to their line qualities. Studying the contours of a form requires an understanding of both outer edges and inner structure. This visual investigation of the significant edges can be linked with a drawing procedure, often referred to as *contour drawing,* which uses a slowly drawn line to record what the eye sees. This process requires a determined effort to slow down the viewing speed and to match that speed with a steady, slowly-drawn line.

A good way to get the feel of this way of drawing is through a series of what might be termed *blind drawings* or *pure contours.* We draw only when looking at an object. The lines we make merely record the eye's investigation of the object. The finished drawing thus becomes a graph registering the path of the eye. These drawings are distorted and disproportionate since eye and hand coordination is almost impossible to match. Our powers of observation benefit immensely from this exercise. By forcing the eye to slow down to a snail's pace, by zeroing-in on the intricacies of each area, the understanding of what we see is amazingly enlarged. The recorded line study is incidental to the experience, but when later used in a controlled drawing the use of line becomes more sensitive and accurate.

Pure contours can be started at any point of an object and can be drawn in various time lengths. Try a few short ones (five minutes) to warm up, and then extend the time involvement to stretch your capacity, twenty minutes to forty-five minutes. Make your eye look at every detail along the path of observation. Don't attempt to draw all of a complicated form; just look and record sections.

After engaging in this kind of seeing exercise, attempts should be made to use the contour drawing technique for more finished results. Whereas you do not have to look at the paper to make *blind* contours, you must use a checking system—that is, you need to periodically see where you are going—to draw *controlled* contours. These checks should occur when you feel that the drawing control is getting away from you. This problem will often arise when an area changes direction or terminates. Try to look intently at what is being drawn, and keep the line and seeing slowed to a painstaking pace. Draw around and inside forms to state what you feel is important. Detail some areas extensively and let a simple line indicate the rest. Once you have this process under control, you can employ it creatively in a variety of situations, such as with areas of value or color, with collages, and with a wide range of drawing and painting media.

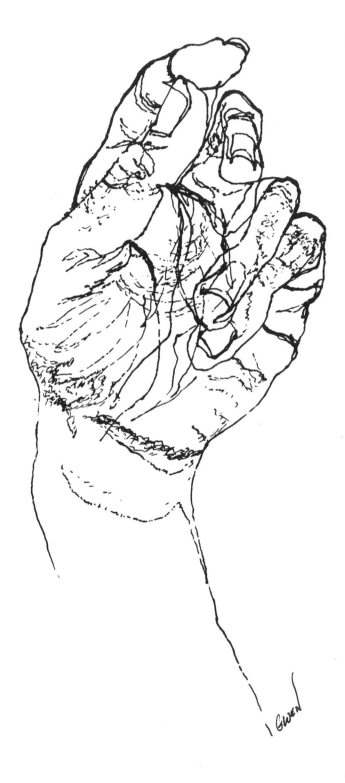

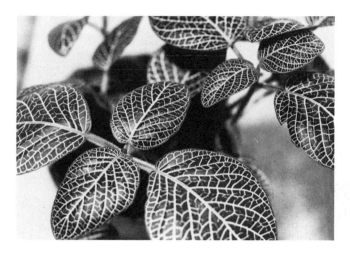

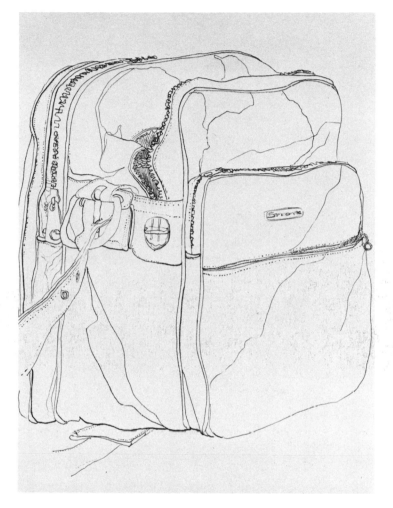

In this felt pen contour study of a hand, Gwen Conway takes in the forms of the thumb, fingers and palm, and the textures of the skin.

Contour studies of lineal objects, such as plant leaves, are ideal for visual and drawn investigation.

A complex contour study by Kip Hagberg reflects excellent observation of the major shapes and details of a carrying bag.

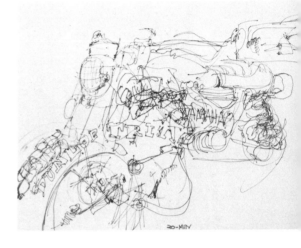

Blind contours of simple objects like scissors help train our eye to observe the important edges of forms. The drawing records the eye's investigation.

Try sections of complicated objects and expect lots of distortion with a "no looking at the paper" drawing.

Charles Lamb's twenty-minute pure contour of sections of a motorcycle is an excellent example of an observation exercise.

Contour line can be selectively employed not only to describe form, but also to emphasize a section. This study by Doug Hill of corn and husks combines charcoal with pen and ink to express a strong dark and light subject treatment.

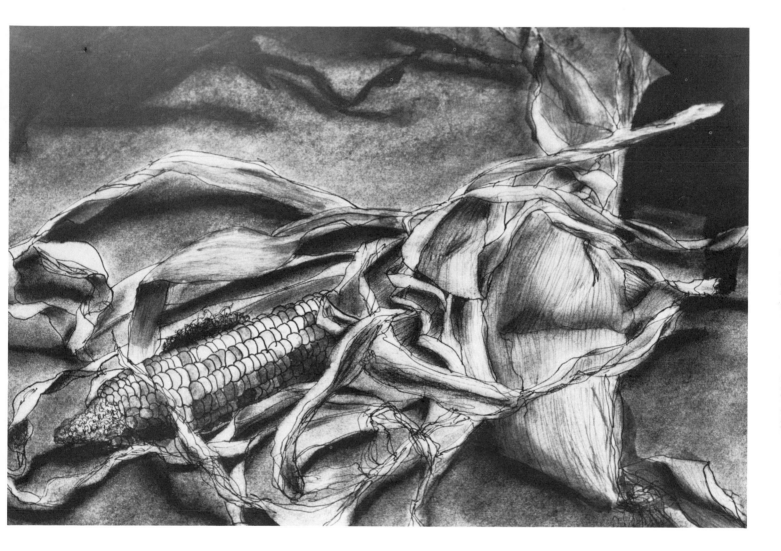

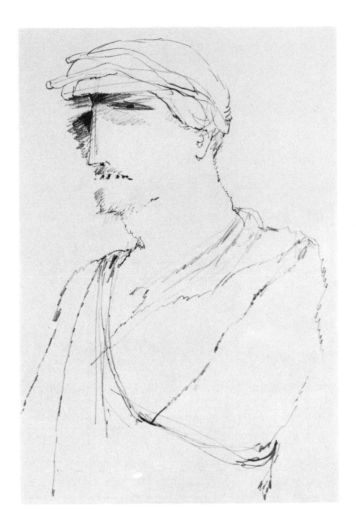

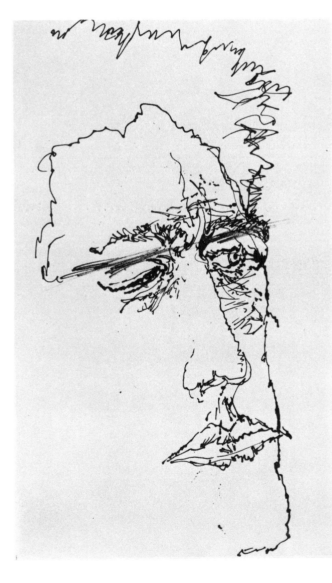

Improvised drawings, using a contour technique, demonstrate the use of felt pen and pencil to capture an *agitated* line quality.

Kay Lew used a confident contour line approach, supplemented with felt pen areas, to depict the inner workings of her father's laundry business.

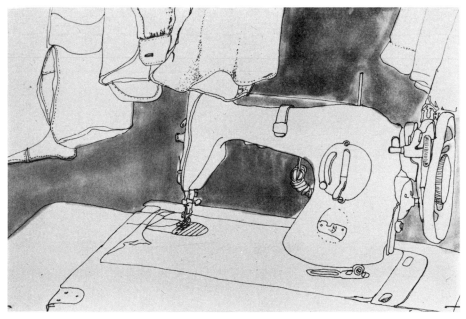

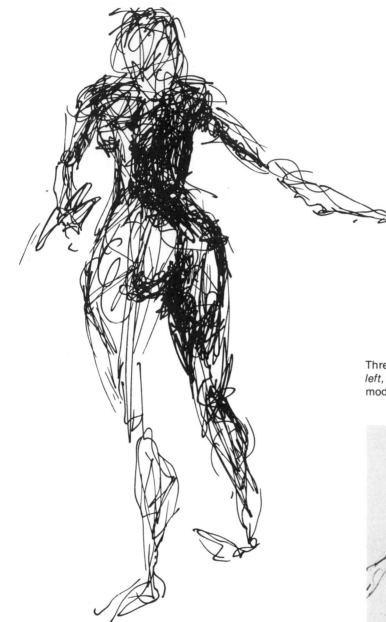

Three action studies use the gestural technique. The one on the *left,* drawn by Monica Christensen, is a quick study from the model. The other two are improvised.

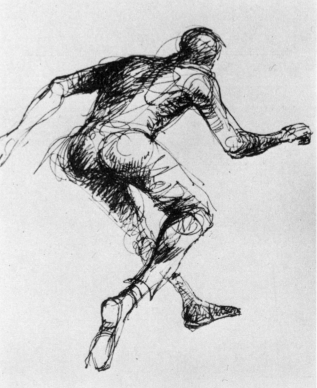

Action Drawing—The Fast, Free-moving Line

Contour drawing demands a slow, carefully drawn line. As a contrast, action drawing or "gesture" drawing is a vigorous explosive line technique.

Action drawing tries to capture the movement and energy of a form, and becomes extremely useful in sketching figures in action. The basic approach is to bring an internal *gut* reaction—that is, a sort of attitude—to an observed movement. A freely-drawn line will register the essence of this movement. Instead of working along edges of forms, the drawing starts inside, moving up and down a central core or spine, and explodes outwards. The line quality is lively and fast-moving.

Drawing time may vary from a few seconds to several minutes. Since the concern is to register action, details are sacrificed for the major factors of movement, bulk, and weight, as well as indications of form placement (forward and back). Line can be massed to create solid areas. This massing of line is useful in depicting weight such as occurs in the trunk of the body. Line can also be built up to push a form inwards or to separate a forward form from one behind.

Once you react to a pose or to something in action, the first step is to vigorously draw the dominant action. From a few quick lines, which act as an armature or base, more line can then be added as you reinforce the pose and explore heavier areas with built-up line. If you can, try to state the whole pose in about ten seconds.

This requires drawing at top speed, and working more from an inside feeling than from mere observation. Action drawings can be easily made of single figures or groups, as well as sequences of actions such as we see in time-lapse photography. After trying several action drawings with the usual pencils or felt tip pens, experiment with a variety of pen points or crayons to discover the many types of line that can be used to express action. After drawing people in classroom or home settings, make action studies in restaurants, parks, at sports events or at some street action. Ask your friends to pose or capture them on the sly.

After you have drawn a number of these situations, it becomes relatively easy to invent your own action studies. A sketchbook near a television can be an excellent repository of those actions on the screen that are intriguing.

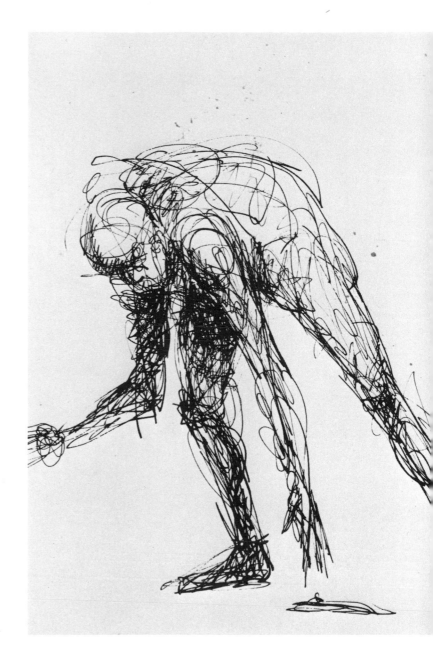

23

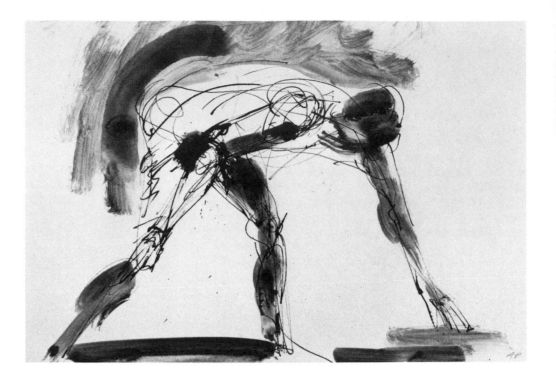

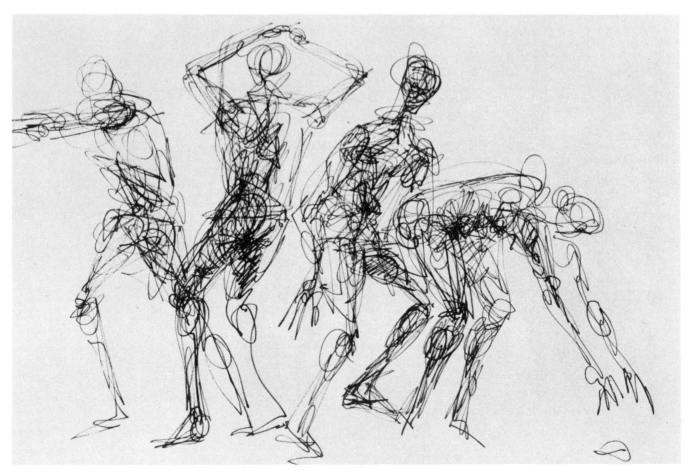

24

Wash and ink line combine to register action and form. Time of drawing was approximately one minute.

Taking a figure through a series of poses can describe a sequence of actions. Each pose was taken for one minute.

Art editor and artist Elin Waite keeps her graphic skill primed with life class studies. Her quick action figure drawings are finalized in a slightly longer study at the *right*.

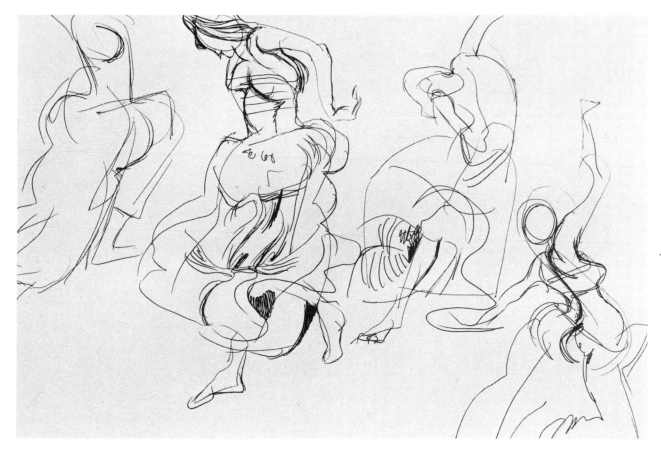

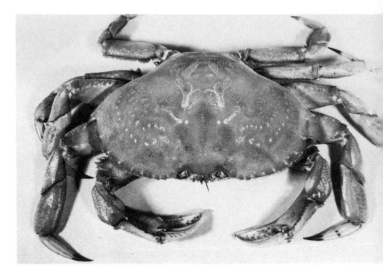

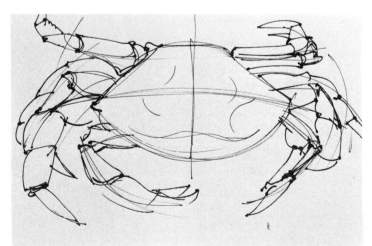

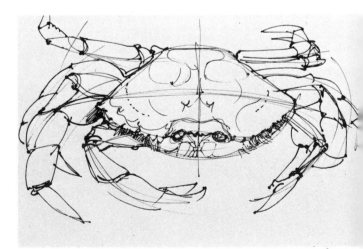

Blocking-in and Building Form

To understand form is to make visual judgments, first about the basic dimensions—length, width and height—then about more elusive factors, such as weight, density, or surface qualities.

Blocking-in a form is a way to make visual assessments carefully. The artist draws several guidelines in order to create a framework that indicates the structure of a form. From this framework or combination of lines and planes, the artist can slowly build up the details and contours of his form. The guidelines may be erased in this process or left as part of the drawing.

Form can also be shaped by grouping lines together either in parallel placements or by criss-crossing line, what is known as cross-hatching. This approach not only creates the shape, but by graduating the hatching from light to dark a stronger three-dimensional appearance is produced.

Many artists utilize a combination of quick guideline indications with cross-hatched or grouped lines to produce darkened areas and to render form. Blocking-in and cross-hatching primarily are line techniques using pencil, pen, or charcoal. Brushes are also useful tools in blocking-in or line groupings. The brush has the added advantage of producing mass with broad strokes. Watercolor washes or diluted ink are excellent media for the sketchbook. Light washes can indicate a shape and subsequent overwashes of darker values can build a solid form. The combination of light wash shapes with superimposed descriptive lines provides the sketcher with a versatile method of translating a variety of subject matter into graphic expressions.

Experimenting with these approaches can offer a good basic method of dealing with rendering form. They should be a springboard to exploring form in more imaginative ways.

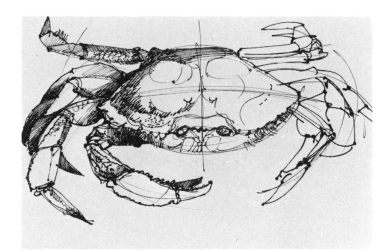

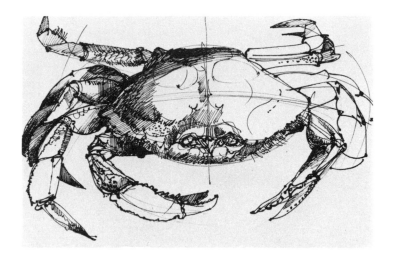

Complex forms, such as this crab, can be broken down into simple shapes. Through the use of guidelines a complicated object can be analyzed. The seven steps show a felt pen drawing progressing from basic shapes to a rendered solution.

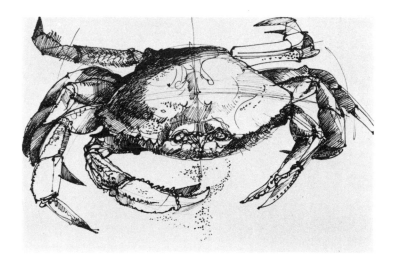

27

Pencil-hatched line can describe a form by building line over line, either in parallel strokes or in diagonal overlappings.

Elin Waite's pencil study of kiwi fruit utilizes both grouped strokes and cross-hatching.

The lineal pattern of pencil strokes creates a handsome value arrangement in this rich portrait sketch. Robert E. Wood makes excellent use of white space to balance shaded areas.

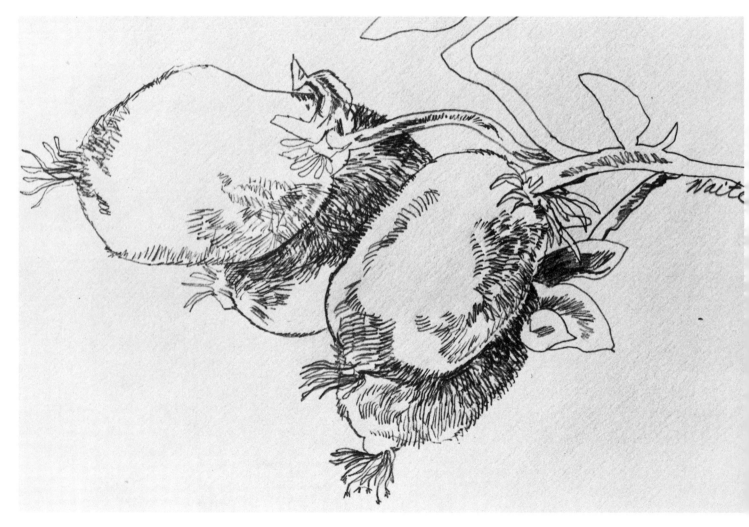

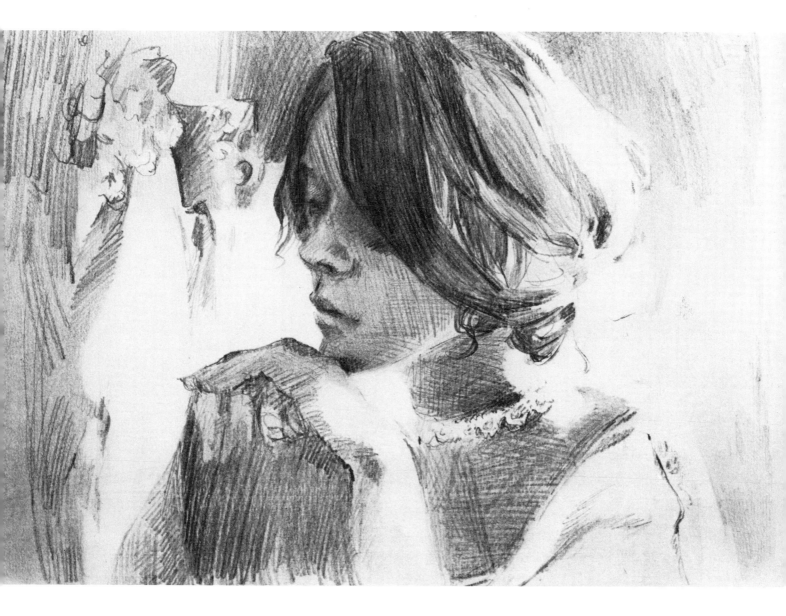

29

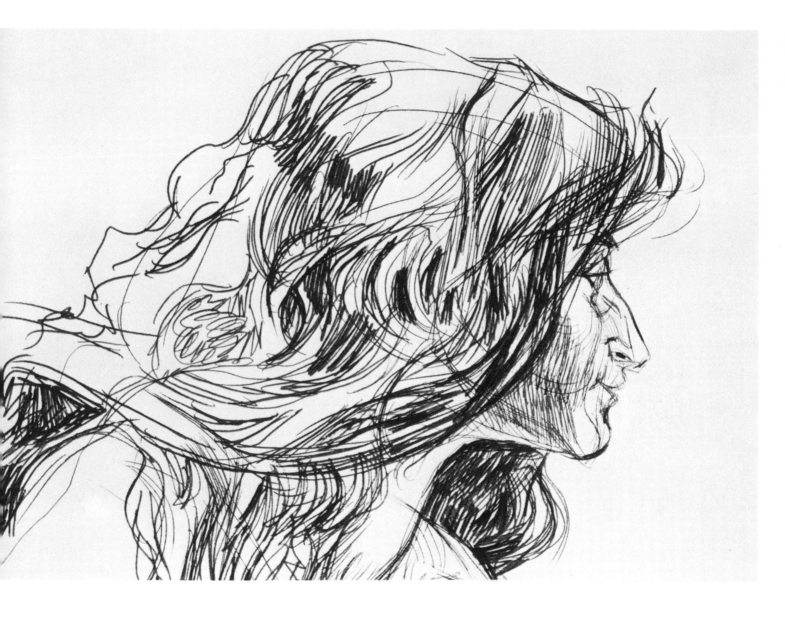

30

Note the sweeping use of pen line in this life study by Elin Waite to describe strands of hair. Lighter strokes were used to model facial structure.

Charles White is noted for his powerful drawings of the black heritage. In these sketchbook studies, he develops a "sculptural" expressiveness with interlacing line beautifully woven into features and hair.

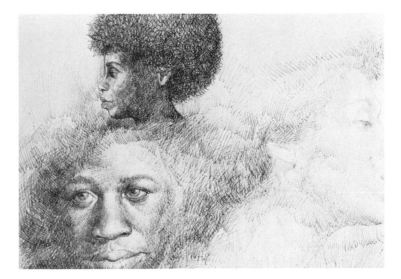

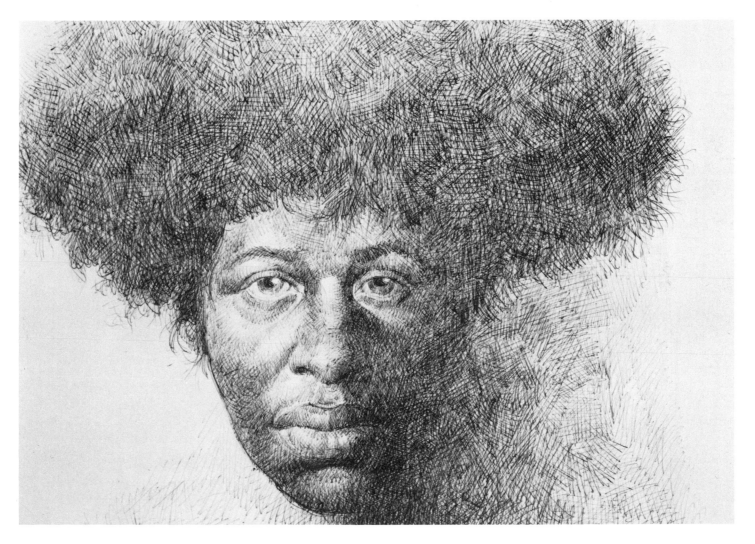

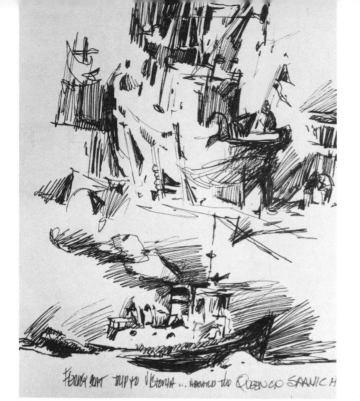

Grouping line against white areas is an ideal way to indicate forms. These two studies of boats by Robert E. Wood capture essential form and a feeling of space.

George James' two explorations of an old house demonstrate his skillful use of line to describe both the structure and solidity of vertical forms.

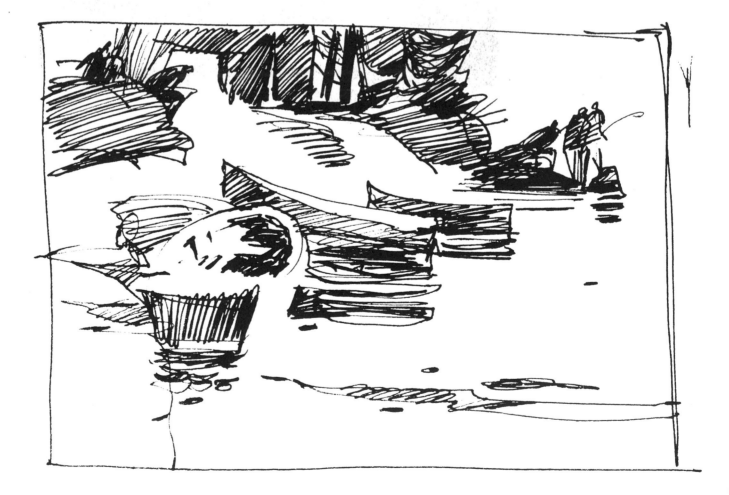

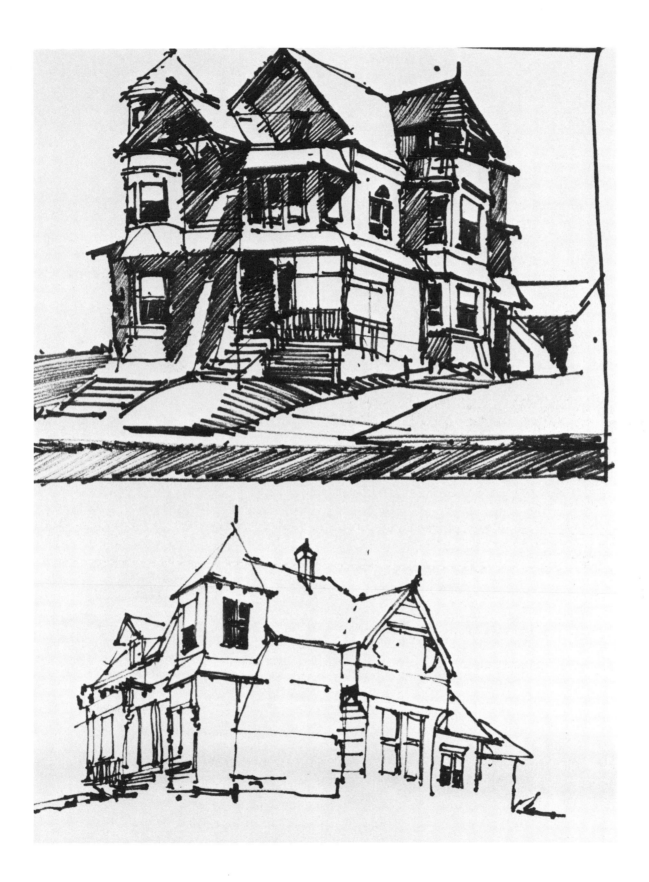

Using Dark and Light

The control of dark and light (value) is essential in creating the feeling of volume and solid form. As we have seen on previous pages, darks and lights are easily achieved by line massing or cross-hatching.

Other media, like charcoal and wash, provide solid masses which can range from light, subtle tones to the deepest blacks possible.

Not only does value explain a form, it can be manipulated to produce strong patterns within a drawing. Value contrasts, such as black and white, can emphasize areas. Suppressed values, such as muted tone, will subdue or subordinate parts of a drawing.

Drawings can be initiated with light overall tones and gradually be brought up to the degree of darkness that appears suitable for the subject. With confidence, stronger darks can be introduced into a drawing at an early stage, and modifying values placed to add tonal richness.

Since darks have power and eye-catching capability, their placement in a composition needs to be carefully considered. They may be used to contrast a light area or to dominate as a dark shape. Darks or lights can be judiciously positioned in a drawing to lead the eye throughout the composition or to an important section or center of interest.

Learning to handle dark and light will greatly enhance drawing facility and will give an added dimension to lineal treatments.

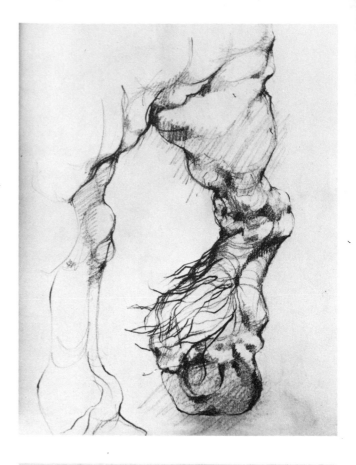

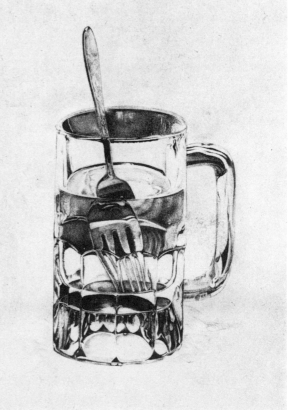

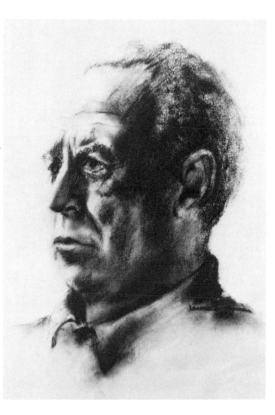

Once a form is defined, areas can be reinforced with stronger values and lineal details. This study of a horse's leg is by a high school student.

Careful use of values can depict the subtleties of glass, metal, and refracted images. A rich range of dark and light has been used to describe a variety of surfaces in this charcoal study by a California State University–Fullerton student.

This high school student's charcoal study of her father uses light, medium, and dark values to define structure. Softened areas give a feeling of skin folds and rounded facial forms.

Rubbing an overall tone over a surface can provide a generalized background or foreground value from which lights are lifted with an eraser. In this drawing by Jane Wood, added darks surround the form to help frame the main focal point.

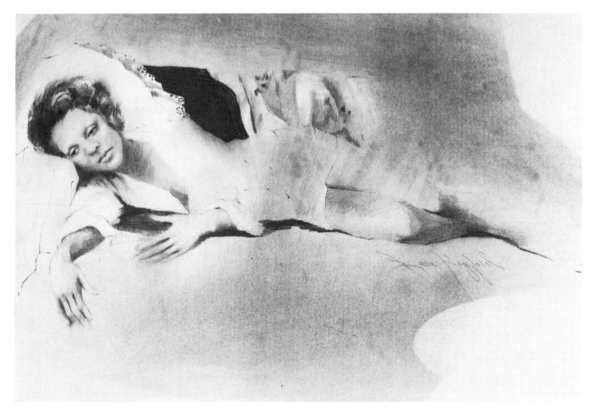

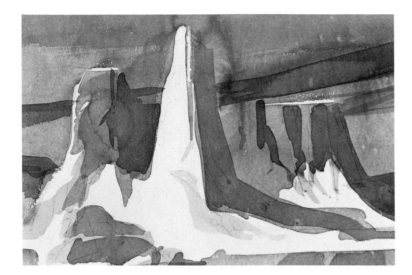

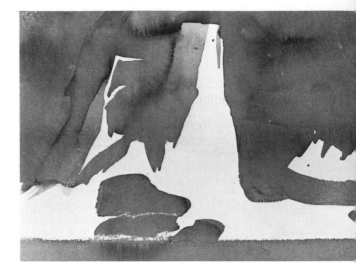

Two masters of the wash technique know how to chisel out form by value wash overlays. Joe Mugnaini builds mountains by isolating white forward areas and adding successive washes to produce a strong sense of form.

Charles White defines the planes of the head by contrasting dark and light areas. He uses a minimum of line to clarify edges.

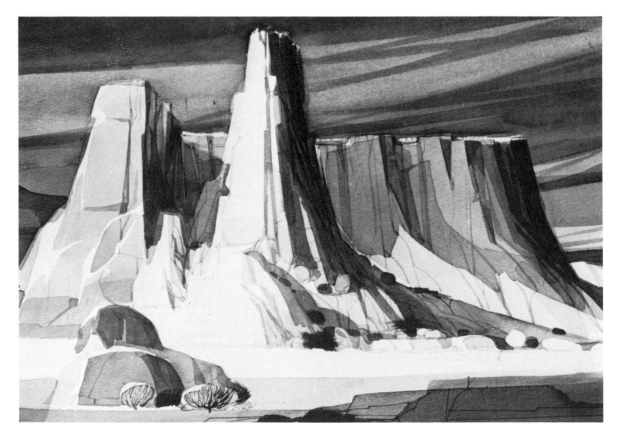

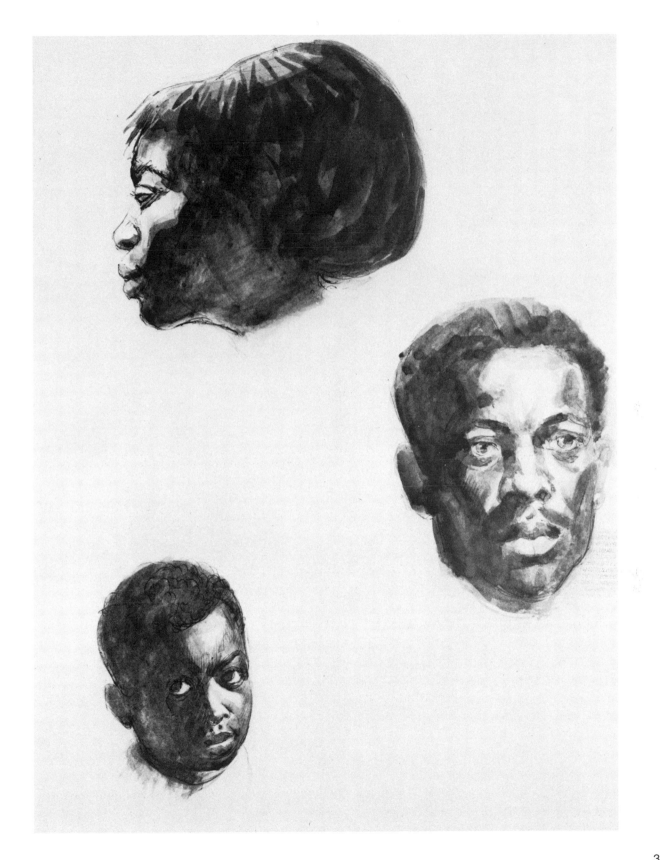

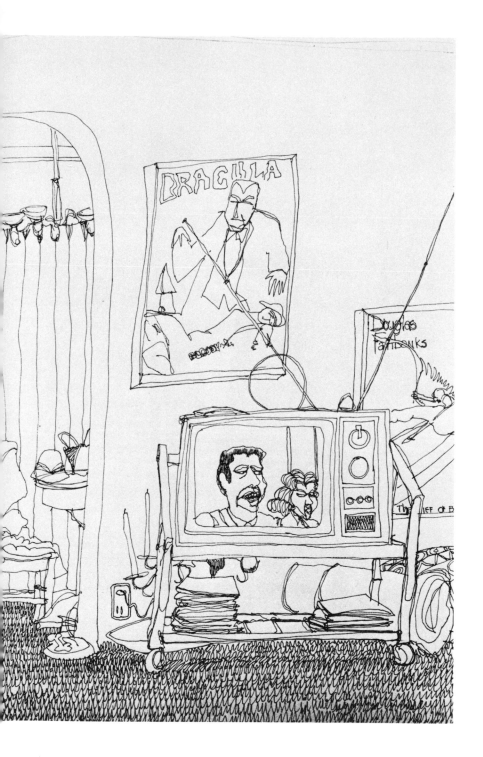

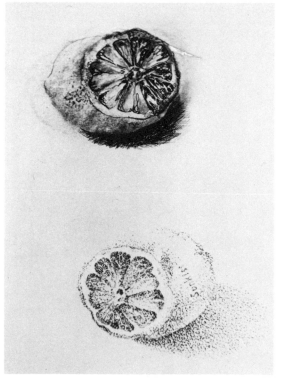

Kevin Burton looked no farther than the television to try his hand at a lineal interpretation of set, program, and wall decor.

Attempt simple line statements, like the kitchen stove drawn by George James, or try various drawing techniques of food items, such as this high school student's sectional views of a lemon.

Where to Sketch?

Where to sketch may seem like an absurd question to pose to yourself, yet so often the lack of challenging subject matter or the inability to approach subject matter is the reason given for not drawing. "I don't know what to draw" is unfortunately a repeated statement. The answer is that subject matter is everywhere, and one need not go far afield to find worthwhile drawing material.

The Home Environment

The home environment can be a good starting point with the local neighborhood and environs as good second choices. Our homes may offer a whole range of intriguing visual material—kitchens and their utensils, furniture, closets of clothes, lighting fixtures, unmade beds, tools and toys, people and pets, plants and bookshelves. Draw some of the things you enjoy since this gives you a positive empathy with a subject. Food is both attractive to the palate and eye, and offers a rich visual potential. You might try a series of sketches of not only the outer appearances of food items, but sections or slices of food as well. A partially eaten apple may present a more interesting shape than the perfectly symmetrical fruit form.

Sketching objects from different viewpoints is also a stimulating activity. Your line of vision can be up, down, or oblique. Capitalize on those moments when your family, friends or pets are in repose. The snoozing person is the perfect model. Other stationary things are also good starting points—the house structure, the yard, parked cars, trees, and plants.

After the home environment comes a host of visual possibilities—local stores, firehouses, parks, restaurants, city buildings, and transportation vehicles. These areas provide an inexhaustible source of images and are particularly valuable for studying people and objects in a variety of situations.

Our vision gets even more charged by new sights. Providing we have a mode of transportation, the exploration of landscape is our paradise. Nature presents an unending panorama of exciting forms, mountains, seas, lakes, forests, plains, and deserts. These kinds of sites provide opportunities for sketching either the vast spacial qualities of the location or a portion of a landscape that is visually stimulating. This selection could be a section of rocks, a stand of trees, or a patch of weeds. It is fascinating to make a series of sketches of a location that involve long views, sectional views, and close-up details. Field trips to such locations can be tied in with a vacation or a weekend jaunt.

After a diversified exposure to drawing a variety of life, we may wish to select specific sites for in depth sketching involvement. From such concentrated investigation can come ideas for finished work—drawings, paintings, or prints.

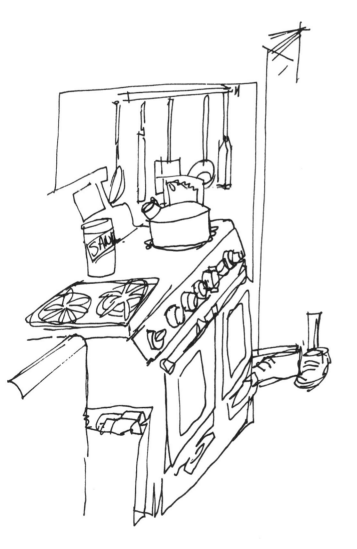

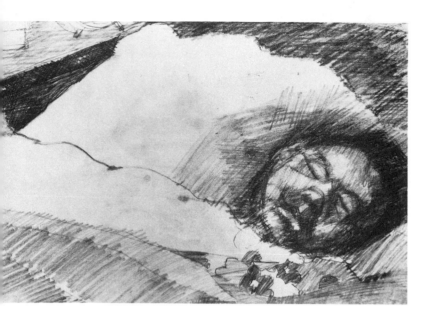

People in repose are perfect subjects for sketching. Sam Clayberger's girl reading on the couch and Kevin Burton's sleeping youngster are fine examples of catching people at the right moment.

A favorite pet offers a good opportunity for drawing form in a variety of positions and attitudes. Dorte Christjansen's cat, Snowflake, is expertly sketched in three positions.

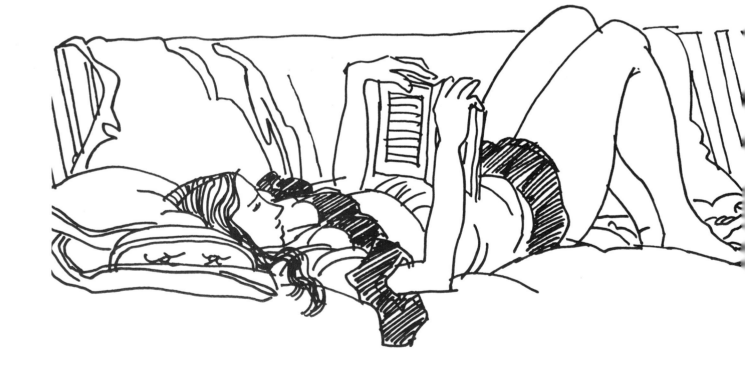

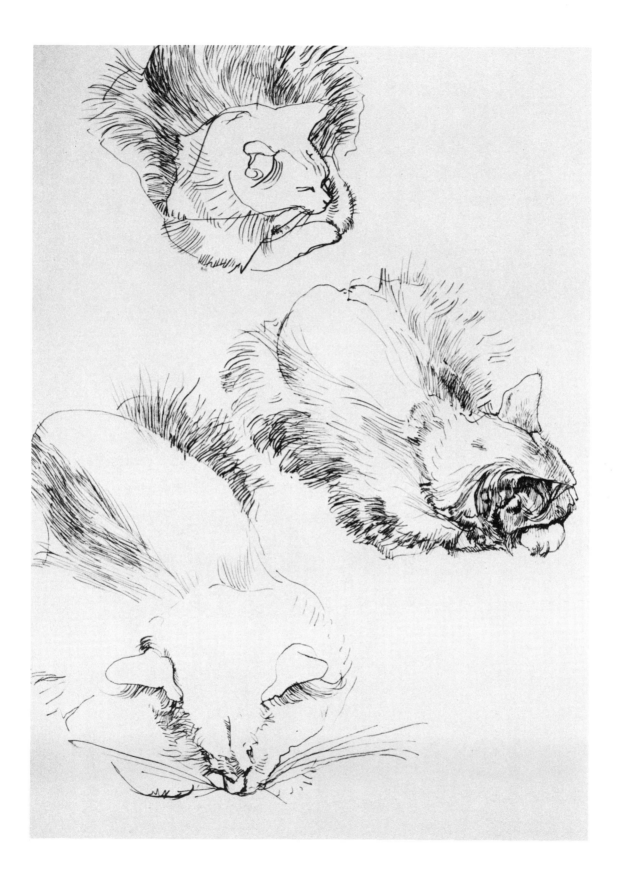

Neighborhood Subjects

A musical program cover became a useful surface for Ed Reep to record a sketch of the local city hall. From such sketches he later developed his concept for a painting using the city hall as the dominant image.

Run-down buildings are fascinating subjects to challenge the sketcher's eye. George James captures the essentials in this bold black and white study.

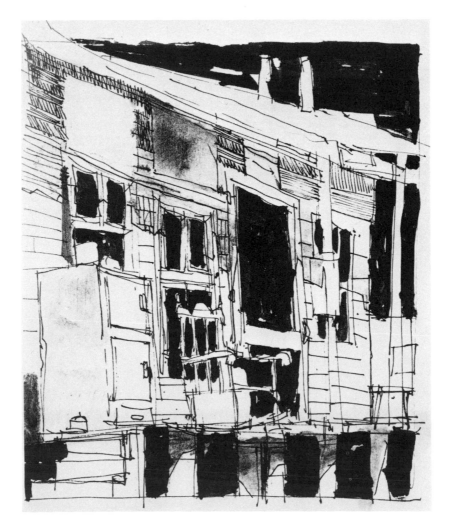

Quick notations of sections of forms, such as this tree study by Kevin Burton, are valuable in increasing our powers of observation and the ability to visually express our selected viewing.

Flowers and plants create exciting patterns and are worthy subjects. This large plant necessitated an add-on sheet to catch its full dimensions in a study by Dorte Christjansen.

Kevin Burton's sketchbooks abound in head and figure studies, many done on location. The above drawing was made during a bus ride. His arrangement of a series of heads gives added visual interest to a page.

Tennis, racket ball, or other sports are good motivators for a fast sketch.

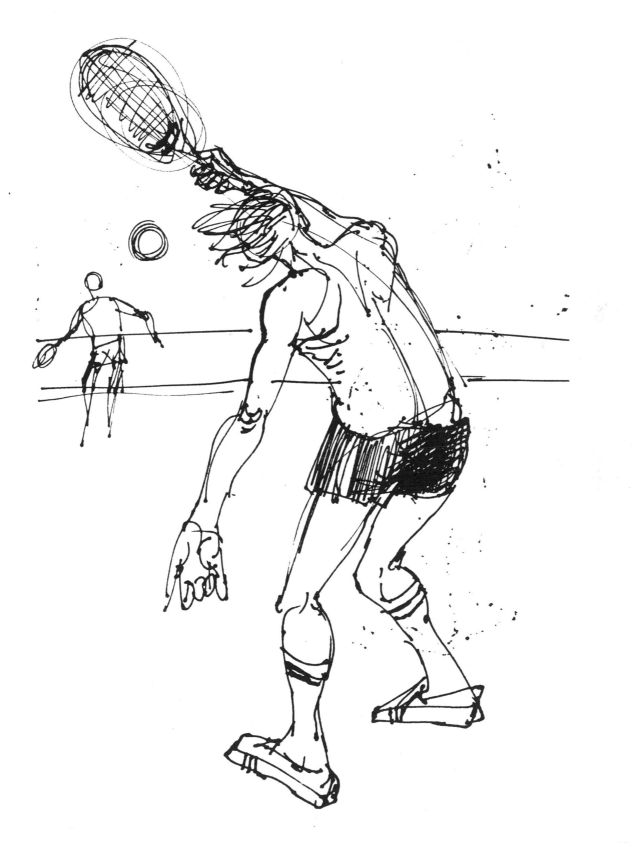

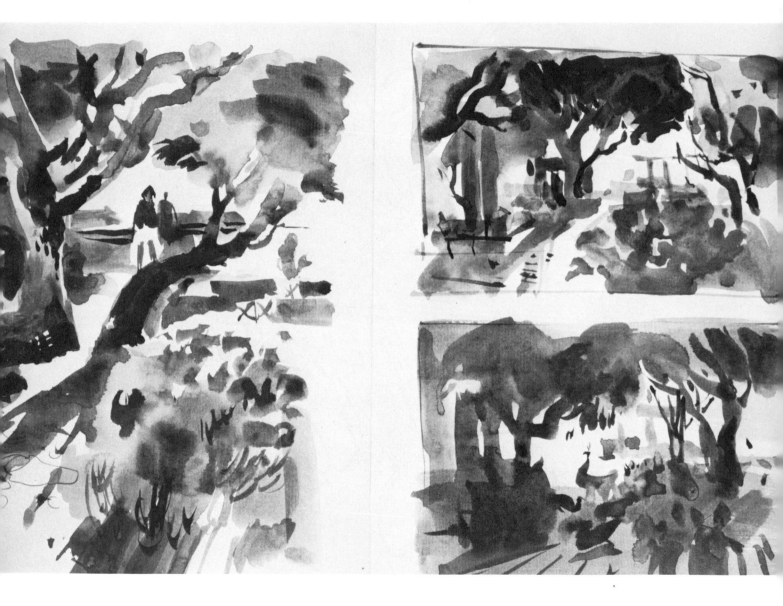

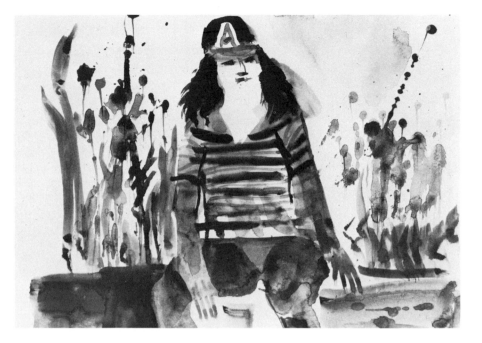

Take your sketchbook to the park and enjoy the possibilities of trying out compositions like these convincing wash studies done by Robert E. Wood

Freely applied watercolor washes can be used to quickly state major shapes and suggest background forms, as seen in the seated figure above.

Joe Mugnaini's pen and ink study of a figure in the park captures essentials with a minimum of lines.

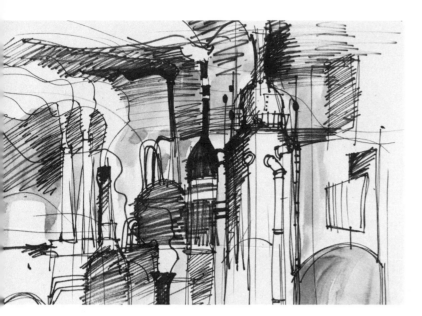

Airport and Industrial Plants

Industrial plants have myriad forms. This section of a refinery was detailed in felt pen and wash, and attempted to extract the power and energy of steam, smoke, and stacks.

Restaurants, bus and plane terminals, are excellent spots to record groups of figures. This sketch by Robert E. Wood catches the essentials of figures, plane, and lounge.

The use of grey to close in on a slice of an industrial scene is particularly effective. George James utilizes strong contrasts and silhouetted forms to dramatize his sketchbook compositions.

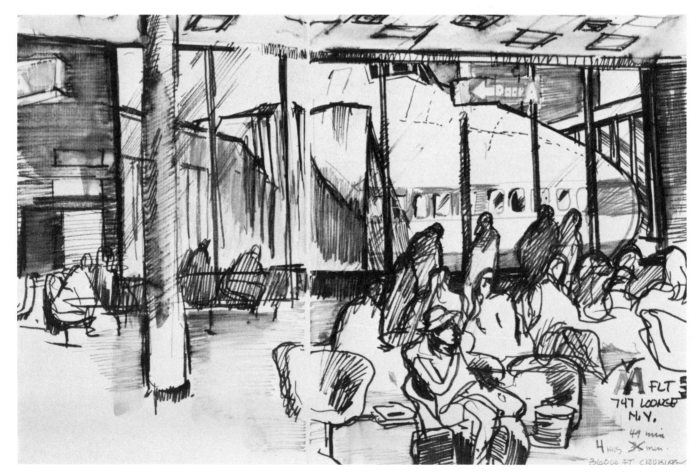

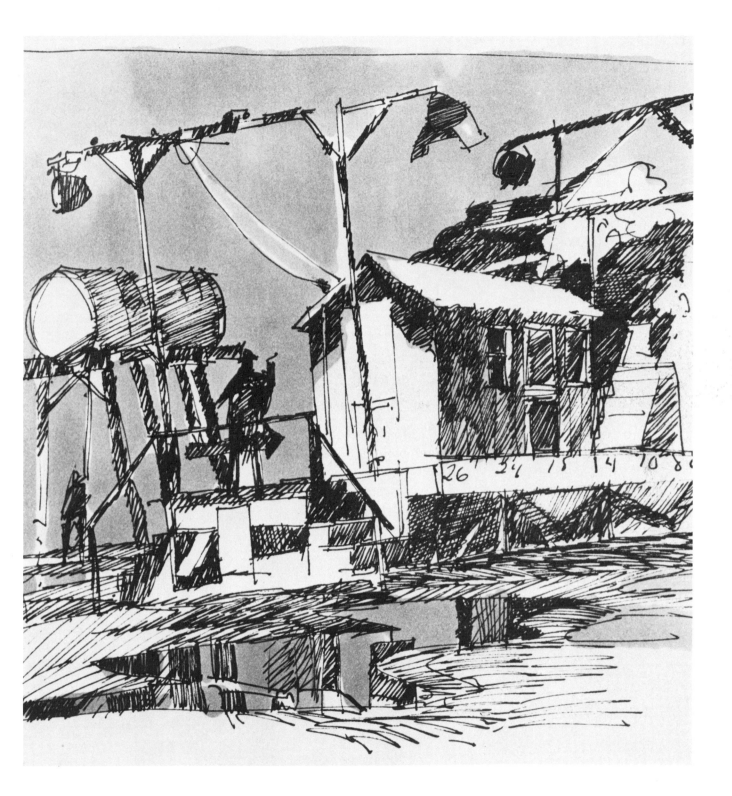

49

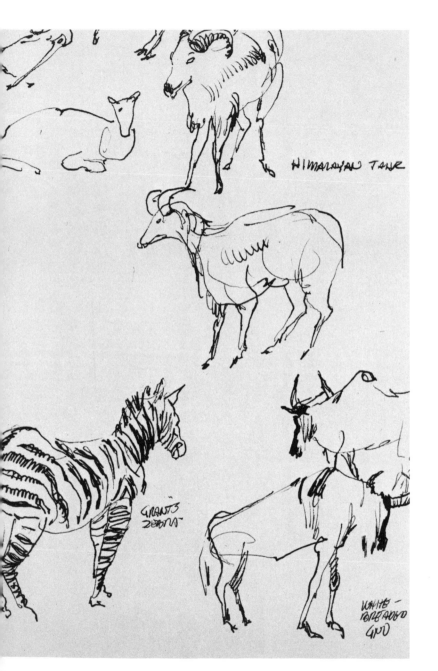

HIMALAYAN TAHR

GRANTS ZEBRA

WHITE-BEARDED GNU

Zoo Subjects

A visit to the zoo with a sketchbook is a profitable venture. It provides a potpourri of shapes, forms, and patterns to challenge the most serious artist. Robert E. Wood, whose previous sketches emphasized figures, capably registers the forms of four–legged creatures.

Elephants make good models. Their movements are relatively slow, and they tend to stand in one spot for long periods of time, giving one ample opportunity to sketch. Sectional details can be taken from several animals. Felt markers and ball-point pens make excellent recording media.

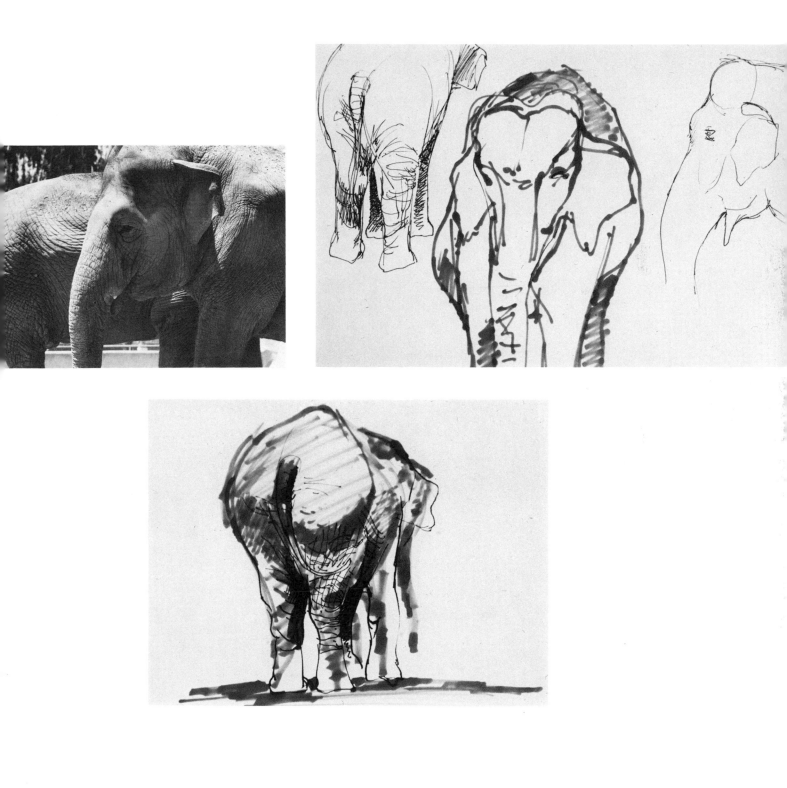

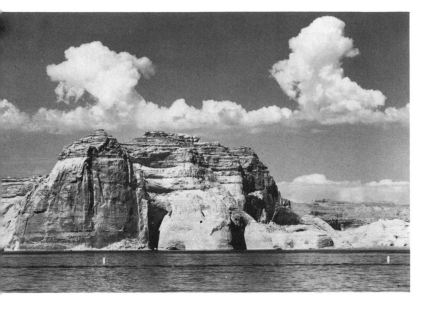

Field Trips

A field trip to an unfamiliar site provides inspiration and fresh drawing material. This site on Lake Powell, Arizona has spectacular scenery including water, heavily creviced buttes, and billowy cloud formations. The sketches on these two pages are reactions to on-site drawing and painting along with several follow-up impressions done in the studio.

Kim Williams makes numerous line and value compositions with descriptive notations. *Opposite,* Joe Mugnaini's acrylic sketch details the fissured mountain forms. The two other sketches are improvisations of the same subject using felt pen, ink, and watercolor washes.

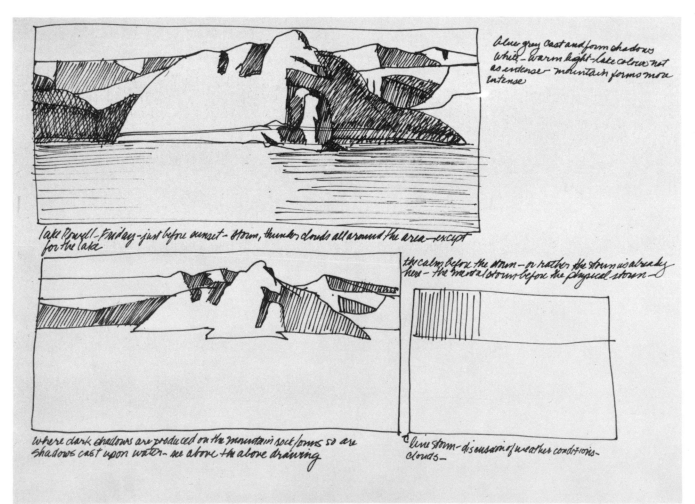

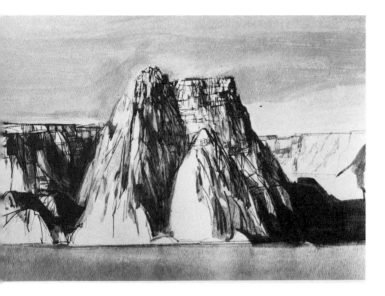

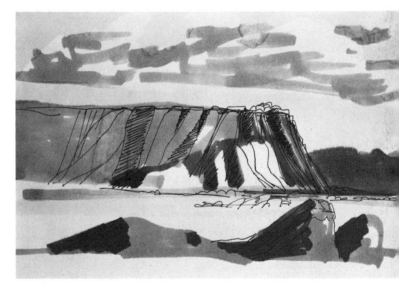

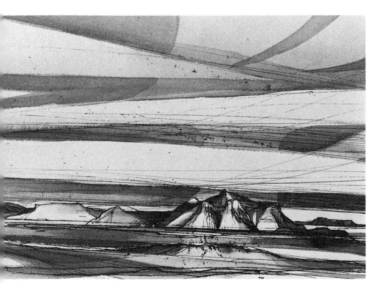

53

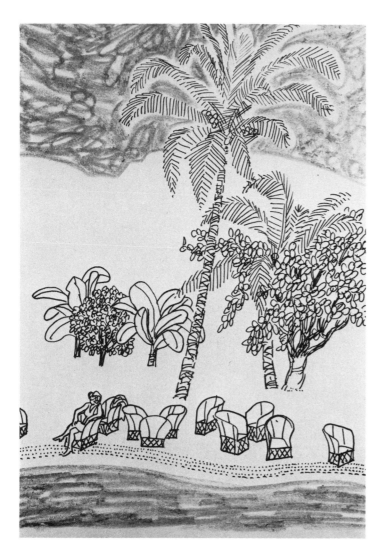

54

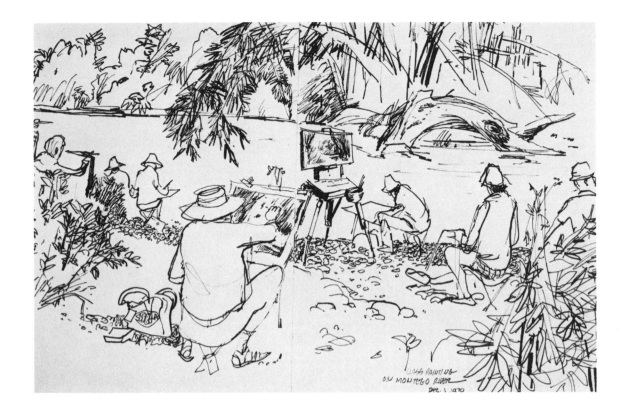

Sketching on Location

Trips to far-off places deserve documentation in a sketchbook. Robert E. Wood, *above,* frequently takes people on painting trips around the world. Sam Clayberger has done a series of sketches in Mexico, three of which are presented here.

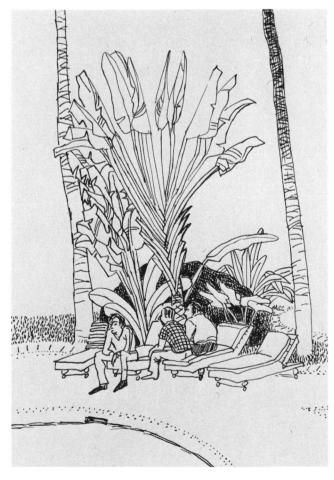

55

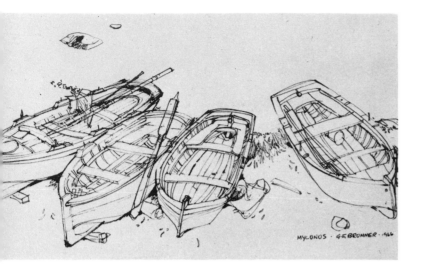

Gerald Brommer's overseas jaunts take him to exotic places. His sketchbooks are alive with clean line drawings and sensitively placed darks. These three sketchbook drawings are a form of information gathering that is aesthetically pleasing.

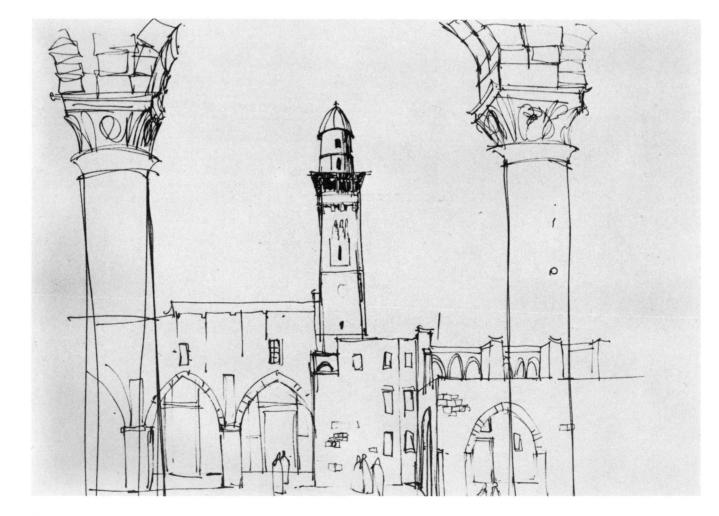

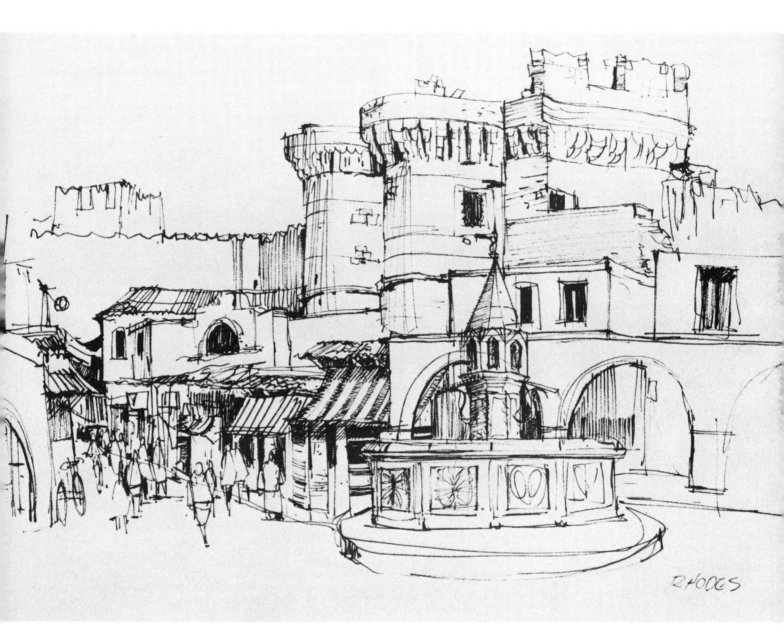

RHODES

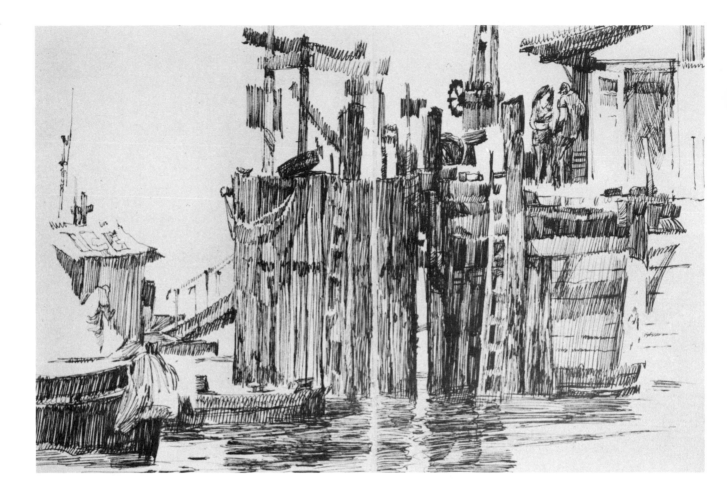

In Depth Study

Some sites are worth revisiting for in depth studies. To draw similar subjects in a variety of locations heightens our skill and perception.

By redrawing a subject, new observations are made, more revelations of structure and form come to light, and the subject matter can be treated in a variety of techniques.

Wharfs are busy, visually active structures that invite versatile interpretations. These three studies by Robert E. Wood show varied approaches, from clean contour line to massed value areas.

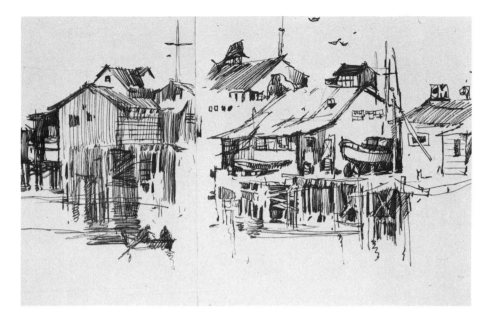

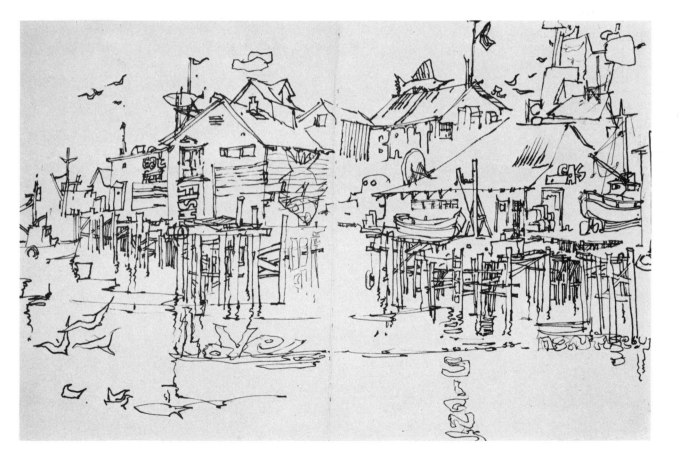

59

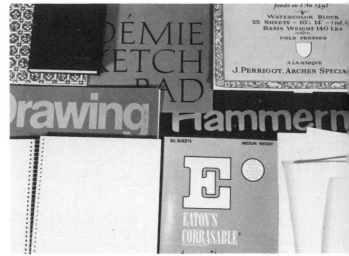

The best way to decide on which paper surface you prefer is by sampling many possibilities. Sketchbooks, drawing pads, water-color blocks, typing paper, bond paper, and even paper toweling all offer their own special qualities.

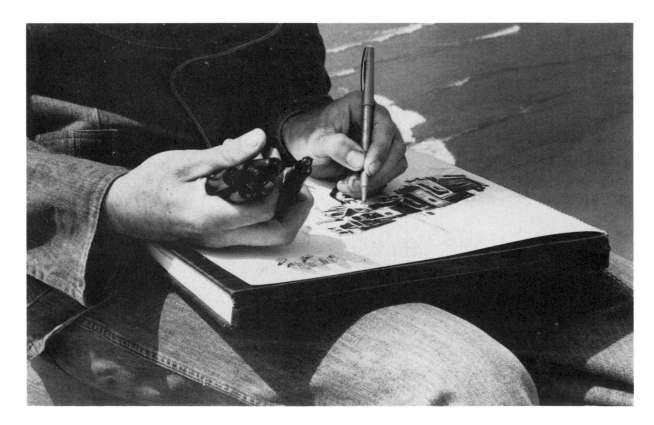

What to Use

The media for sketching are so varied that the biggest problem may be to find a reasonable limitation that doesn't tax either your pocketbook or storage facilities. The best approach to expanding one's drawing resources is to start with a basic supply and to add to it as need and curiosity suggest.

Sketchbooks and Papers

Drawing surfaces can range from paper towels to fine bristol board. Within this range is a vast number of papers that ideally fit a sketcher's needs. Probably the most convenient is the *sketchbook.* These come in either spiral, sewn, or permanent bindings. The spiral book can be opened flat, and the paper easily extracted. Sewn or permanent bound books store well, and give the option of working across two pages. A pocket-sized sketchbook (4'' x 6'') has a small format, that precludes expansive drawing, but is both convenient and excellent for carrying around inconspicuously. More useful sizes are 9'' x 12'' and 11'' x 14''. These paper surfaces are smooth and receptive to pencil, pen and ink, markers or light washes. If more extensive wash or watercolor work is planned, heavier and more toothy paper (watercolor type) is required.

Bond pads are excellent for larger work, and come also in various size formats. Typing or mimeograph paper can work well for quick sketching, and is relatively inexpensive.

For the watercolor sketcher there are heavier papers designed for wet media and extensive washes. These papers are available in large single sheets, pads, or blocks.

Charcoal paper is designed for charcoal, conte crayon, or pastel. Its tooth and grainy surface catch and retain these soft dry media. Try several brands and surfaces of paper, and find the surfaces you find most receptive for specific treatments.

Pencils and Erasers

Pencils come in a wide array of value degrees that provide line and area qualities that can meet the most demanding conditions. H pencils are hard, B's are soft and they range from 9H to 7B. Those in between solve most requirements. In particular, 2B, 4B, and 6B are soft and give strong blacks; 2H and 4H are for light, harder line qualities.

Also in the pencil line are *charcoal* points, also graded in degrees. *Carbon pencils* like charcoal give powerful blacks; being more powdery, they can be smudged or softened either by hand, eraser, or chamois cloth.

Pen points in holders, using India ink, give rich flexible lines and dense blacks. Colored inks expand the spectrum of line and area treatment. Points are usually flexible,

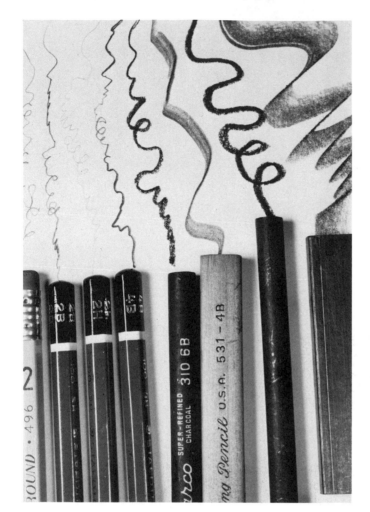

Using Pencils and Erasers

Pencil leads range from hard (H type) to soft (B type), and give an excellent range of values. Charcoal pencils or sticks, plus graphite are also good for both line and area treatment.

An undulating surface can be achieved by gradations from light to dark.

Shading is easily accomplished by light overlays and pressure change.

By pulling an eraser through a pencilled area, Dana Lamb has created the feeling of movement and water.

In his bird studies, Dana Lamb demonstrates how pencil shading can build form in either subtle or sharply contrasted areas. Surfaces can also be softened by rubbings.

affording line width changes by pressure and the amount of ink used. The finest points are crow quill, and one can move up through medium to heavy line points. Chisel points (C type) can produce a thin side line or a flat wide front surface line. Speedball B points make a consistent width line though pressure and reversing the tip offer variations. A number of different weight points should be experimented with to ascertain their effectiveness for sketching. One of the most useful sketching implements is the *marker pen* which is now produced in a host of points, widths, and colors. Some are felt points, others are steel or nylon. Wide felt pens, whose points have a chisel edge, can be helpful in filling in broad areas of either value or color. Markers are easily combined for convincing effects.

A number of *fountain pens* which take either India or fountain pen ink are also available. Their flexibility and capacity for refilling are advantageous.

Added to these basic media are *erasers* (gum, pink pearl, and kneaded) which not only eliminate unneeded line, but which may be used to draw into toned areas. Particularly useful is the kneaded eraser, which can be pulled into various shapes and points to lift out either small areas, or to clean up large surfaces. The lack of crumbling is an added benefit.

Crayons and *pastels* are softer media and can be a welcome addition to achieve color effects. Crayons are generally crumbly and pastels smear readily, so surfaces must be remedied by brushing off crayon bits, and fixing pastel with fixative or acrylic spray. Despite these drawbacks, both media are a welcome change of pace. They can easily be mixed with other media and in particular with ink line.

Wash or *watercolor* are two wet media good for the quick sketch. Wash can be merely diluted ink or produced from a tube or pan of watercolor. You may want to start with an inexpensive box of watercolor and later move up to permanent tube color used on a palette or mixing plate.

Brushes are necessary items for any wash or watercolor treatment. Camel hair or oxhair types are inexpensive, red sable (finest and long lasting) are costly. A numbering system, which varies with brands, starts at low numbers (0, 2, etc.) and works up to #12,14, or 22. The pointed type is preferred since it serves both line and area techniques. Flat brushes may be used when large areas of wash are considered. Inexpensive Japanese brushes are good when a calligraphic line is desired and flexibility is not important.

To round out our needs, we will need a box or carrying bag for outdoor work and water container for wash work. A drawing board or working surface (chipboard, masonite) is helpful for larger sheets, and masking tapes and clips keep paper firmly secured. Some or all of these media give us a running start for our sketching activities.

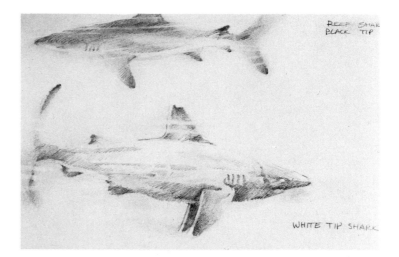

REEF SHARK BLACK TIP

WHITE TIP SHARK

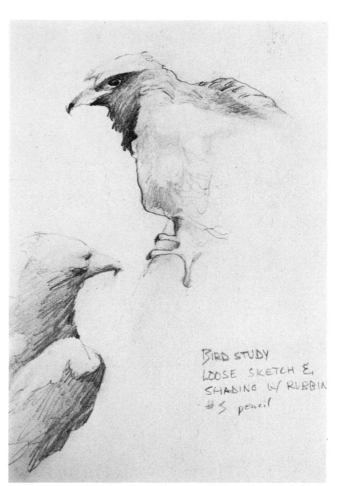

BIRD STUDY
LOOSE SKETCH &
SHADING W/ RUBBING
#5 pencil

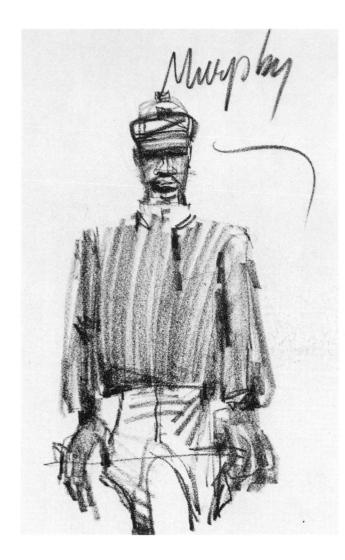

Charcoal

Along with the convenient and relatively clean functioning charcoal pencil, are a large number of compressed charcoal sticks that produce rich velvet blacks and a range of broad strokes. They, like pencils, are numbered to designate the degree of softness (or blackness), and are usually rated from 00 (very soft) up through 5 (hard). White, grey, and black chalks have similar qualities to charcoal and are available in a series of light to dark sticks. Conte crayon works much like compressed charcoal, but is useful for more detailed work. The sticks are slender, can be easily pointed or worn to a lineal edge, and are fairly clean to use.

Stick charcoal is generally used to capture major forms and masses. It can be modified or softened by rubbing with the hand or a piece of chamois cloth or paper. Kneaded erasers can pick out light areas or make a line. Since charcoal is a grainy medium and produces a smearable surface, drawings need to be fixed by either charcoal fixative or acrylic sprays. Light coats of these sprays can be used throughout the drawing process to keep a smudge-free surface. Charcoal can be combined with other media such as ink, but its chief value is in its powerful range of darks, and in the ease with which it covers areas. If getting good contrasts in your work has been a concern, then working with charcoal will greatly increase the range of values, and will tend to loosen your approach to drawing.

This sketch by Bill Pajaud epitomizes the power of charcoal to deliver a quick statement. Note how the vertical strokes easily suggest the jockey's shirt.

Charcoal sticks easily produce broad areas of value. This quick study of seashells suggests general forms and creates a sense of unity among them. This effect is achieved by connecting paths of dark or light. Small line additions help to clarify edges of forms.

Two students at California State University, Fullerton, have made very subtle interpretations of form with the charcoal medium. Surfaces, such as the paper bag, or glass and plant life, have been effectively analyzed by a careful selection of values.

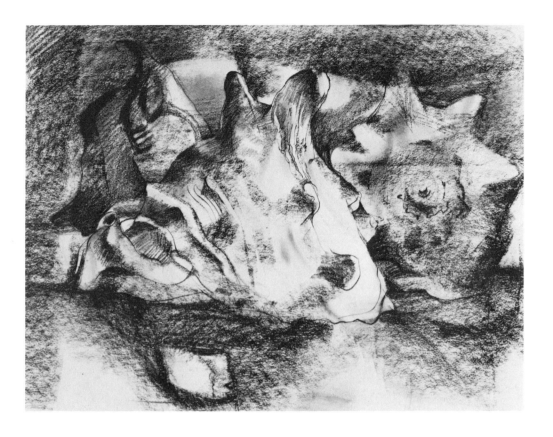

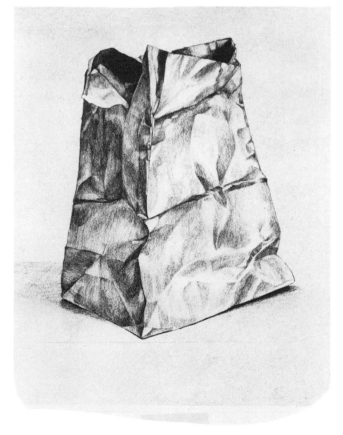

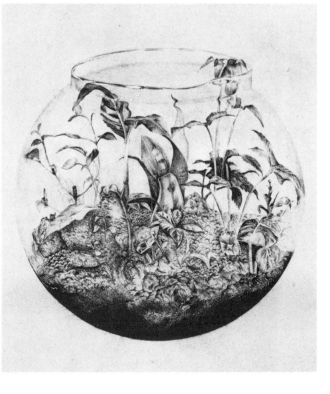

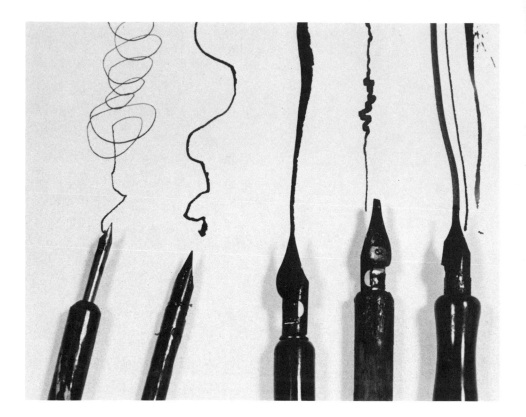

Pens give a variety of line qualities. Thin delicate line is characteristic of the crow-quill pen. Medium steel points are flexible and give both thin and thick lines. Chisel points like C-3's can register either thick or thin line by turning the pen. Speedball B points generally give a constant line.

Sketching fountain pens carry ample ink supply which can be refilled.

Pen and Ink

For pure vigor and lineal excitement, pen and ink are hard to beat. Since ink line is almost impossible to eradicate once it is applied, it forces us to approach drawing with the necessary bravado and confidence that are essential to sketching effectively.

With practice, pen and ink can be used with the same ease as pencils, and the extension of our creative capacities is considerably enlarged by the flexible nature of this medium.

Once again the range of points is extensive. They are usually made of springy steel that give a rich line flexibility produced by simple pressure changes. In general, points come in the shape of a pointed thin triangle with a lineal slit for spreading the ink. The weight and size of the point determine the width of the line.

Other points feature either a rounded point or a chisel end. Rounded points, such as Speedball B points, are often used for lettering since the line is uniform. If the point is rotated (side or back), line widths vary. This process is useful for drawing subject matter like trees where line widths vary significantly from the trunk to the leaves. C points or chisel points range from wide to thin line by simple rotation.

Inks are made for permanency (India ink) or to be soluble (fountain pen type), and can be purchased in a broad spectrum of colors. If one tires of black and white drawing, colored inks and watercolor dyes are excellent stimuli for lively line drawings.

Discover the excitement of pen line by exploring with many of the point options. Some introductory doodles will apprise you of the potentials of each point, and initiate the feel for pen drawing.

Although bamboo pens, twigs, shaped chopsticks, and barbecue skewers carry India ink for only short periods of working time, they can produce intriguing, textured lines. Pulled strokes deliver the ink to the surface smoothly, pushed strokes create broken line, dotting, and spattering.

Pure exploratory experiences with line make us more fluid with media. Doodling with pen and ink is one way of freely playing with patterns and forms.

Flung or spattered ink or wash gives a feeling of force and energy, and may form textural patterns suitable to subject matter surfaces.

Brushes are vital tools in interpreting form. As we see in this brush study by Joe Mugnaini, large masses can be blocked in and supporting lineal detail can reinforce the main shape.

Delicate pen line is descriptive of this seashell form. Value washes flow in and out of the form in this contour drawing by Andrea Vardanian.

Brush and ink give bold line possibilities. Scott Wessel uses a heavy line treatment to express engine parts.

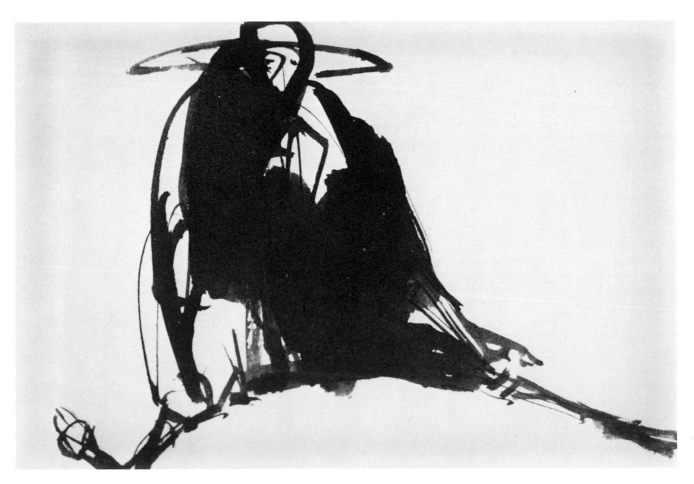

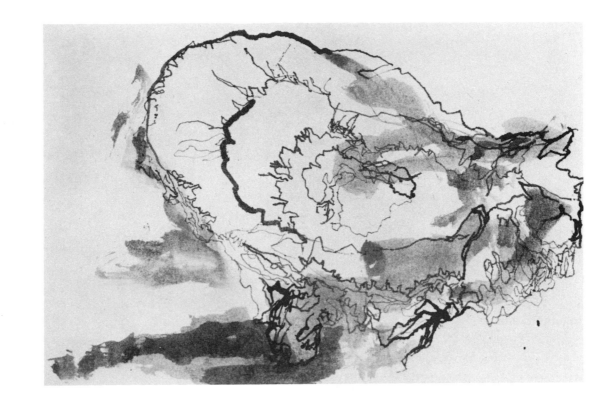

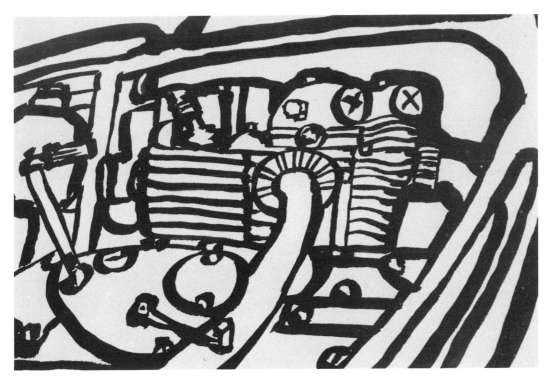

Ink and Wash

George James strengthens his pencil studies by adding black ink to assist in contrasting shapes and forming patterns.

Handsome effects are gained by the combination of line and wash. Note Charles White's sensitive use of light and dark to modulate form.

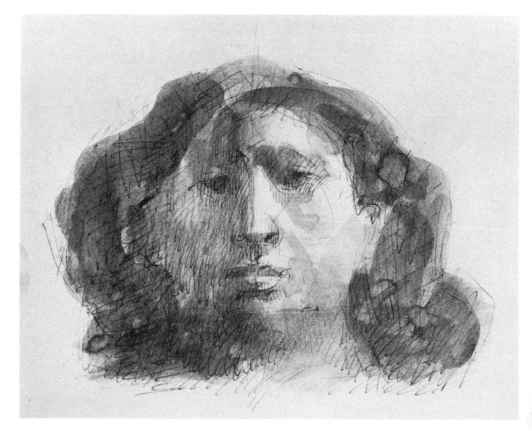

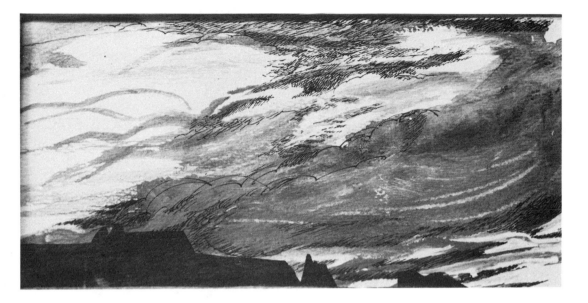

Joe Mugnaini uses wash and ink, both painted and drawn, to get at the essential aspects of this landscape.

Imaginative fish forms, drawn initially in crayon, have been overlaid with watercolor washes. When dry, ink line details finalized composition.

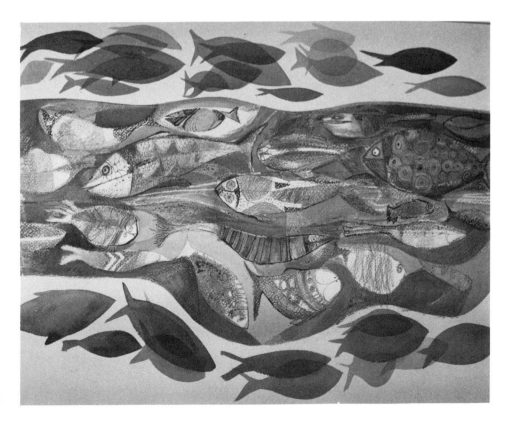

71

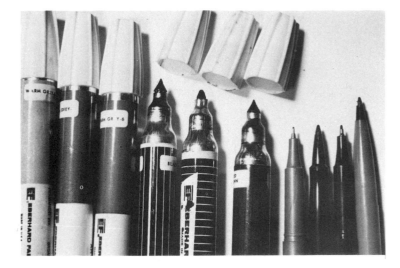

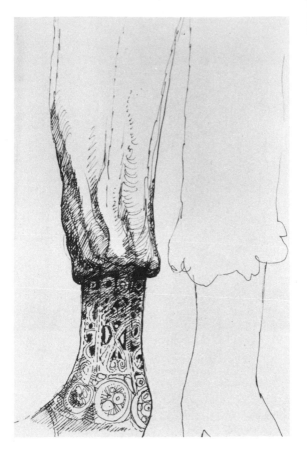

Markers can contour an edge of a form or be used to detail involved patterns.

As we see in George James' study, broad felt markers are excellent for quick washes. Here, he uses them to depict the background area behind the group of turkeys. Marker line also works well to strengthen and define ink or watercolor washes.

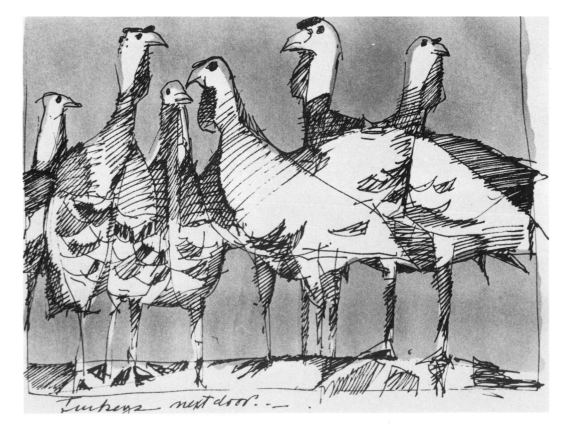

Turkeys next door.

The convenience of markers is hard to beat for sketching trips. Robert E. Wood's marker drawings of figures in Northern Africa have been partially modified by simple wash overlays. Water-soluble markers can be dampened with water to fuse color and suppress line.

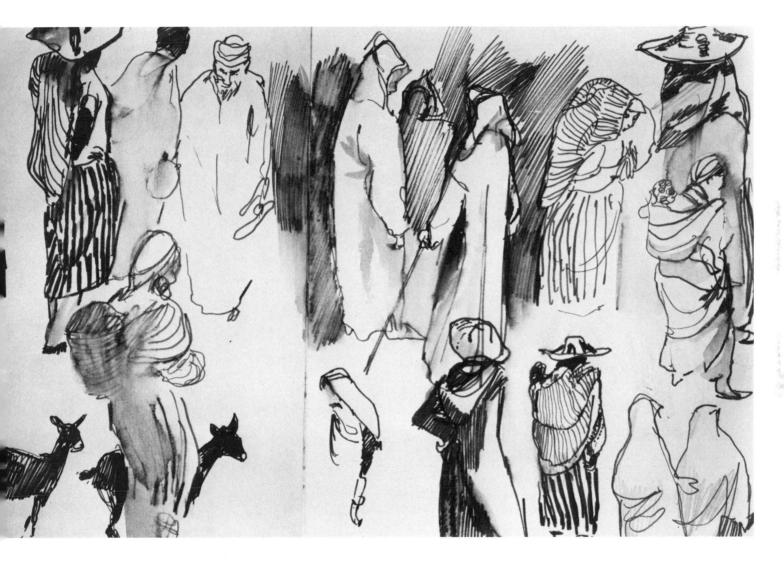

Marker Pens

The easiest sketching implement is a marker. Its long-lasting ink supply is fed continuously through a variety of points. The resulting line or area is conditioned by the type of point material. Felt markers give a soft and diffused line, and when dry, a lighter textured line. Nylon or plastic points have a crisper line and tend to remain constant and firm throughout their life span.

Large quantities of values or color can be acquired in sizable cylindrical containers. They are useful in applying broad areas which work particularly well to either reinforce a line drawing or to function as an underbase for line overlays.

Marker pen drawings on paper towels by Ron Battle utilize the rough surface to achieve texture and line bleeds.

Kevin Burton blocks in dark, bold areas, like the hair and background section in this sketch with a felt marker. Line forms a strong pattern.

An almost dried-out marker pen gives a textural line. This quick drydock study uses such a tool to suggest shapes and shaded areas.

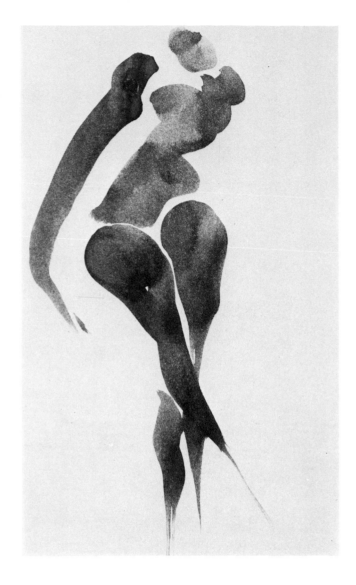

A wash study can simplify major forms as we see in Bill Pajaud's sketches of a figure and mouse.

Test out the value range of various color by plain washes of different value, by gradations made by additions of more color or water, and by wet-into-wet color blends.

Watercolor wash is an excellent medium for quick value experiments. This page of building studies explores many compositional possibilities for future paintings.

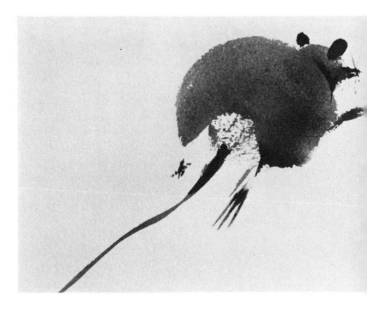

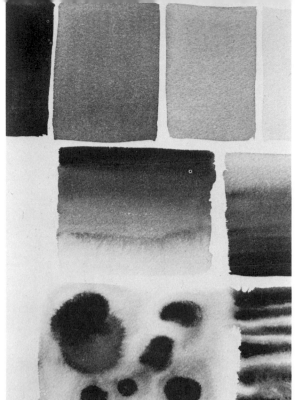

Using Wash

Watercolor boxes with pans of color are inexpensive and convenient for the sketcher's kit of materials. After sufficient moistening, color can be thinned with water and applied as either wash area or line. Tube color is more expensive, but can be permanent and richer in color offerings. Tubes of dark color are good for wash and can be squeezed out on a plate or palette as need arises.

The usual approach employs brushed-on light areas which are modified by overlays of darker value. Insertions of darks into a wet area of light or medium value (wet-into-wet) produce blends and blooms that register softer textural qualities.

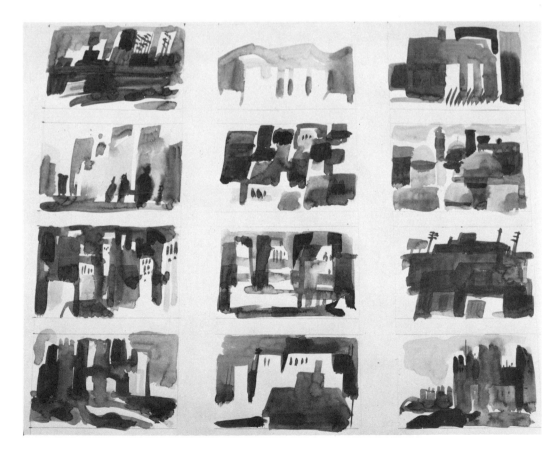

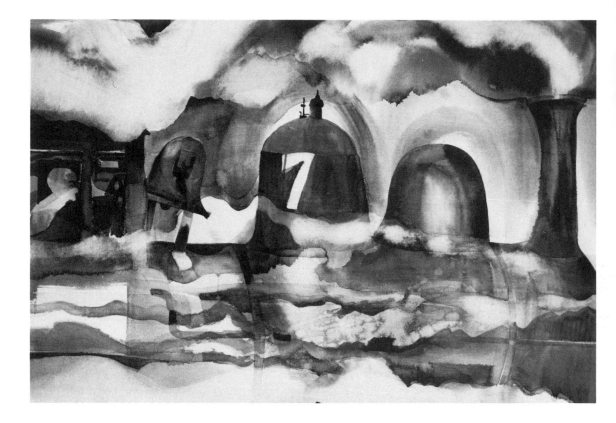

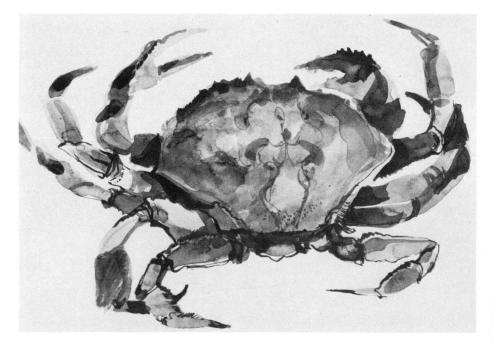

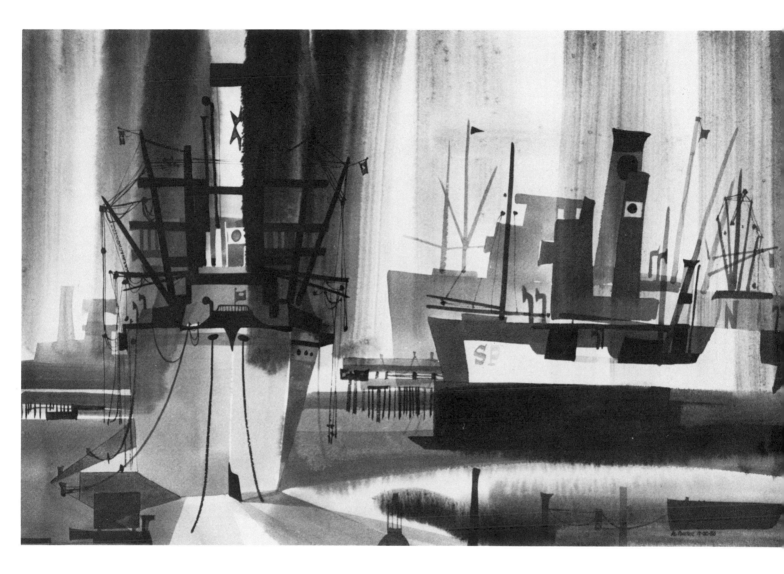

Two watercolors point out how washes create design aspects produced by brush manipulation and wash control. The ship study started with initial wet-into-wet vertical and horizontal washes, and was detailed with dark wash overlays and line additives. The locomotive section was primarily developed in the wet-into-wet stage. Sponging and lifting out areas helped to suggest smoke, steam, and movement.

A crab study used over painted washes to mold form and separate and define areas.

The Color Sketch

Although sketching is often thought of as a black and white experience, the use of color in sketching can be a natural extension of the drawing process. Color is such a dominant element in our visual life that to preclude its use in drawing is to deny an important visual stimulus. Color sets mood, creates intensity, identifies specific activities and forms, and gives a wide range of subtle nuances that can lift a sketch to high levels of aesthetic competence.

The color media for sketching are extensive. From simple color crayons, they range into whole spectrums of pencils, inks, dyes, watercolors, acrylics, markers, felt or plastic point pens, colored papers, ad infinitum. Most of these can be easily combined for rich results.

Sampling several media to find those that feel right or express your particular approach is a good start. Then, add to your supply as you feel the need for a change of pace.

Color may be used extensively in sketches or limited to a selected area. A spot of color can draw attention to an important focal point in a drawing. Bright, intense colors, such as some reds, oranges, and greens are demanding. Others, like the earth colors and deeper hues (browns and blues), tend to be more muted. The sketcher should employ color for the effect he wants to convey. Vibrant activity requires brighter and more intense color, peaceful or more somber subjects suggest muted color.

Mixes and overlays of color give added richness to hues, and experimentation with color intermixing, blending, and greying is necessary to utilize color effectively.

It is important to try using color with a variety of subject matter such as still-life sketches, life figures, home environments, and the outdoors. Sketches in color sprinkled throughout a sketchbook add a lively quality. These sketches may be ends in themselves, worthy of a frame, or they may key our ideas for future paintings or other finished work.

Varying the Approach

We see in these studies the use of color and several media to depict bird forms:

Muted color supplements an ink sketch in the descending bird form.

The careful pen and ink rendering by a high school student is emphasized by a strong orange background.

A watercolor wash study by Bill Pajaud captures the essence of form with loose washes and judicious line insertions.

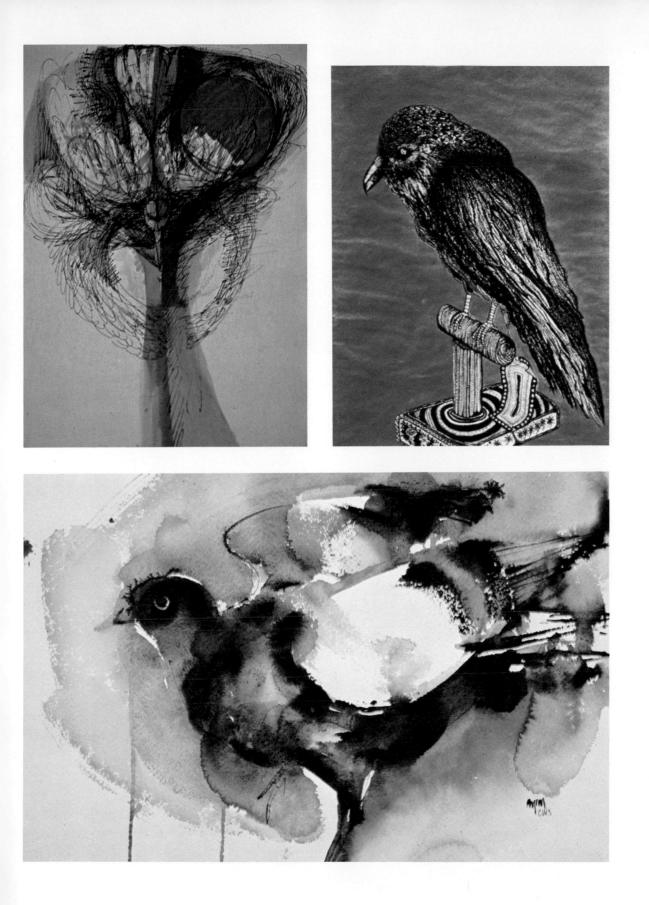

Figure and Color Interpretations

Colored inks and dyes are powerful agents for color intensity. This sketchbook study by Charles Paige makes the most of strong color areas, and line and area patterns to create striking design compositions.

A self-portrait study by Jan Nordland uses colored paper to define areas of the face and hair and overlays contour ink line to define features.

The high school student's interpretation of a figure in the bathtub uses color lightly and descriptively to separate tub water, tile, and bath mat areas.

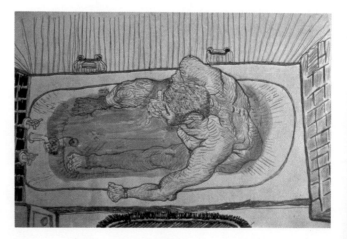

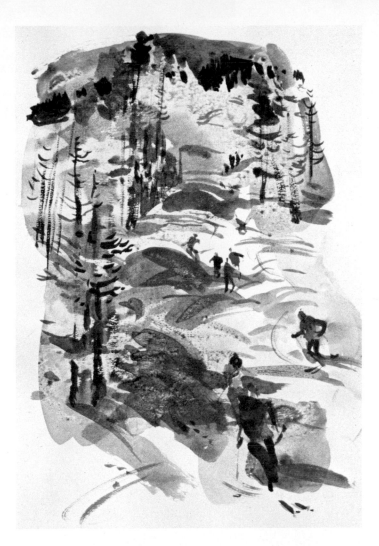

Ski enthusiast and painter Robert E. Wood handles watercolor and marker pens with finesse as he describes ski slopes and figure groupings. Note the fine use of space achieved by figure placements and color accents.

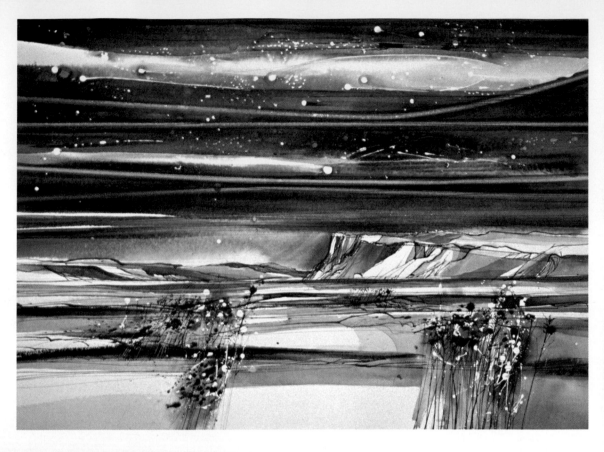

Landscape Color Studies

Shooting stars, lineal patterns in the sky, and weed growth combine with desert hills to dramatize a landscape composition. Media include watercolor, drafting tapes, liquid frisket, and ink.

Sam Clayberger's improvised landscape and figure sketch presents a strong overriding mood that results from cool, greyed color and stark landscape shapes.

The use of white space is an essential compositional element that Robert E. Wood expertly applies to this study of snow.

These two ink and watercolor sketches, made in Europe by Joe Mugnaini, demonstrate the richness of color, line, and values that can be achieved from on-site drawing.

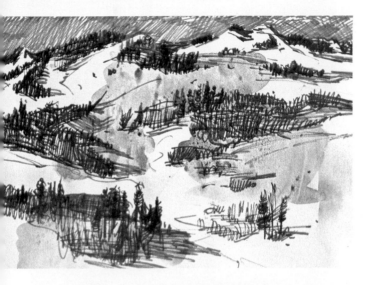

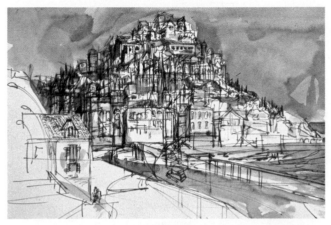

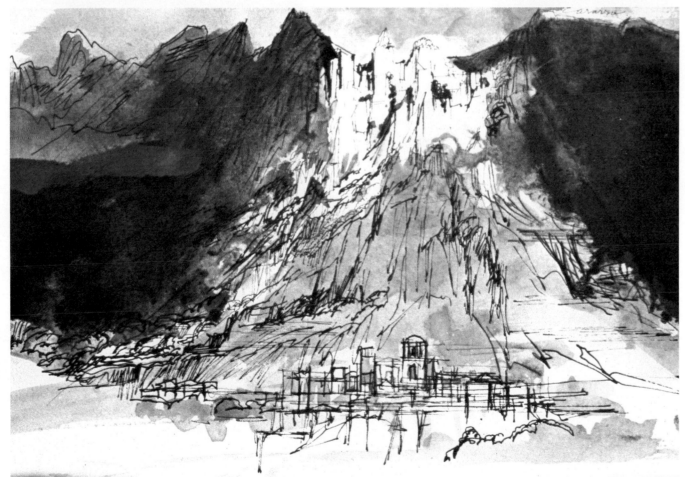

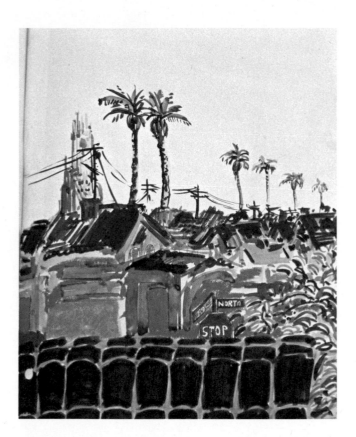

Studies in the Environment

Out of the window sketches or nearby views can offer intriguing subject matter. These three studies are neighborhood sites that a high school student *(upper left)* and Charles Paige found worthy of investigation with watercolor and line.

Whether it grows outside or is something to digest at a picnic, color studies can grasp the visual essentials. The garden onion patch is a watercolor by Bill Pajaud; the beans and foil plate is a watercolor and marker pen study by Charles Paige.

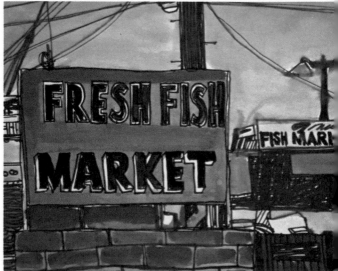

Color from Magazines

Images can be selected and transferred from colored sections of magazines to a blank sheet by the use of lacquer thinner as a releasing agent. Thinner is brushed onto the back of the surface to be transferred as it rests on the paper. After sufficient soaking, a burnishing tool, like a spoon, is rubbed vigorously on the wetted back surface to release the color image on the underneath side. Be sure this technique is done in a well-ventilated area as lacquer thinner fumes are potent.

Transferred images can be worked into with pencils, inks, or markers to heighten effects. This transfer design was done by a student at Villa Park High School, California.

The Inventive Approach

What triggers an idea, or an impulse to draw imaginatively, is difficult for most of us to define. Whatever produces this marvelous, inventive happening, often referred to as the creative process, it is a veritable gold mine of stimuli for sketching. We have all experienced a visual or auditory event that unexpectedly brought to mind a totally unrelated or perhaps forgotten moment of the past. This mechanism of free association and the use of subconscious reations can be explored as an idea generator for sketchbook activity.

Without any preconceived ideas, you can start a drawing by just the random placement of lines. Subsequent build-ups of line will start to establish a feeling of suggested forms. These images can then be further clarified by more reinforcing line and value. Detailing may bring the image up to a recognizable subject matter. This process is like looking through a camera lens that is out of focus, and gradually sharpening that focus until the right amount of clarity is reached.

Playful arrangements of line, forms, patterns, or textures are valuable experiences when varied and imaginatively done. It is fascinating to break up a sheet of paper with shapes, either geometric or free form, and embellish these shapes with lineal patterns or textures, letting your mind freely explore any possibilities, however unique they may be.

Shape distortion should be tried. This can be done by stretching or compressing form. Distortion may produce a humorous effect, or a more powerful image. It is an artist's way of achieving a stronger statement. Cartoonists capitalize on distortion to get their points across. Fashion figures are usually drawn a head or two taller than normal height to produce a more elegant look. Sculptural forms are stretched to emphasize their spacial dimensions. The illogical placement of subject matter often creates an imaginative solution. Flying elephants are impossibilities, but they may be fantasies worth enjoying. Unusual viewpoints, like looking through the wrong end of a telescope or imagining what Alice in Wonderland felt like as a diminutive being looking up at a supersized mushroom, challenge our spacial orientation. Challenge yourself by drawing subject matter from atypical viewing levels—so close that only a section can be seen, overhead or from an aerial viewpoint, underneath or from a variety of angles. Pretend that you are out in space, seeing phenomena from an ant's-eye view or looking through structures that partially obliterate or frame the world, such as windows, doorways and archways.

The point is, all ways of conceiving and developing visual ideas are important to sketching ability and creative growth.

Our imagination allows us to conjure up unique ideas as we see in the sketch by Dana Lamb.

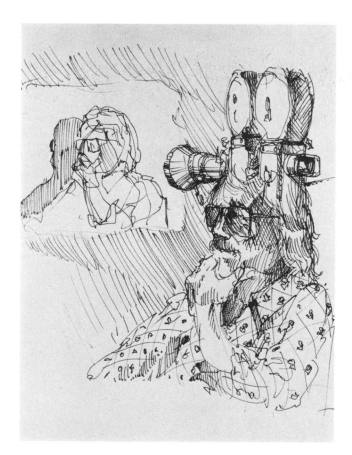

Let some of your work be purely imaginative, and try to make some aspect of inventiveness enter into most of your work. A sketchbook is, for the most part, a visual diary without rigid guidelines. Learning to improvise, to stretch the imagination, is an essential aspect of graphic development. Without it our work can become trite or repetitious.

Sketch by Kevin Burton.

This page of mixed images and play with forms demonstrates the creative process. Film maker and graphic designer Carm Goode allows his inventive ideas to flow through his sketchbook drawings.

90

The Inventive Process

Sketchbooks are forms of visual diaries where one can express highly imaginative ideas and visual experiments. On this page, graphic designer Marv Rubin jots down his thoughts on creative growth and supplements words with a reinforcing visual image.

As Marv Rubin's sketchbook studies reveal, inventing with line or incongruous images is the way to develop imaginative muscle.

ON DIARIES: (PROGRESSIVE POINTS)

① Is each page better than the last?

② Does each page reflect the learning experience of the previous pages? (this is probably more significant.)

③ The previous points don't allow for experiments which must fail some or most of the time. Only if experimentation is restricted to outside the diary, can the diary be consistent.

Lamp design
stacked objects.

Ball point &
Mongol
pencils

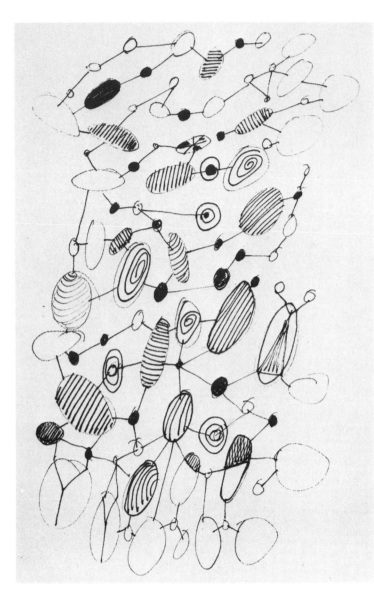

'Doodling and Inventing Compositions'

A page of ellipses, connecting line, and line pattern fill-ins is a playful, informal approach to inventing and composing.

If you have a yen for monumental form, try sculptural shapes or mountain forms. Explore inner as well as outer surfaces.

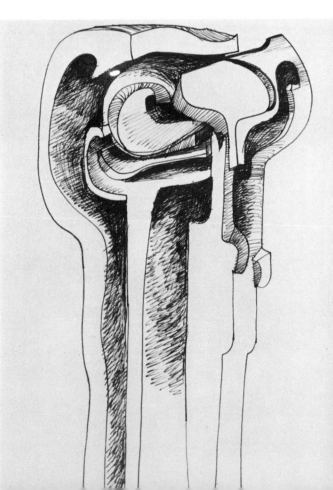

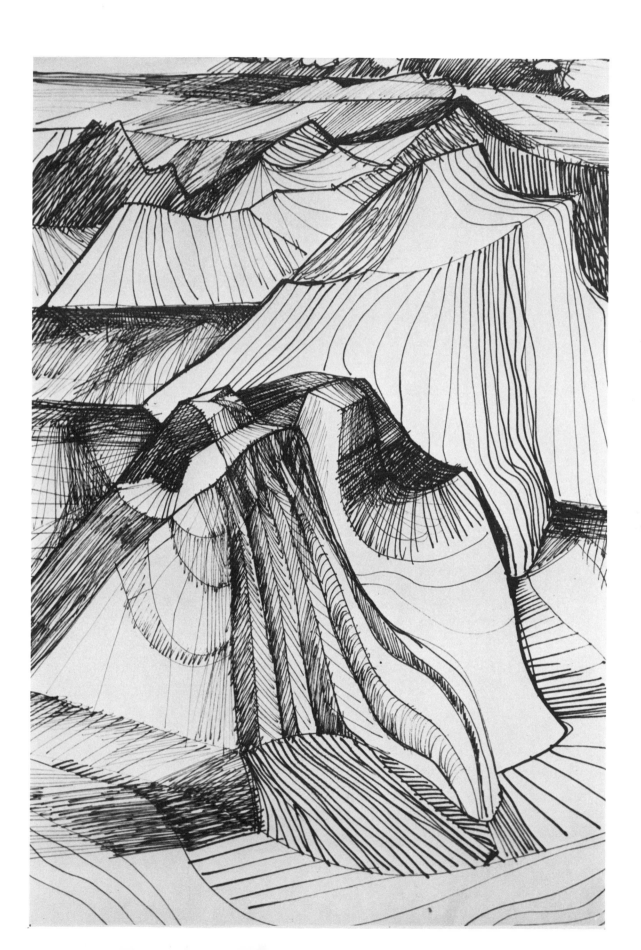

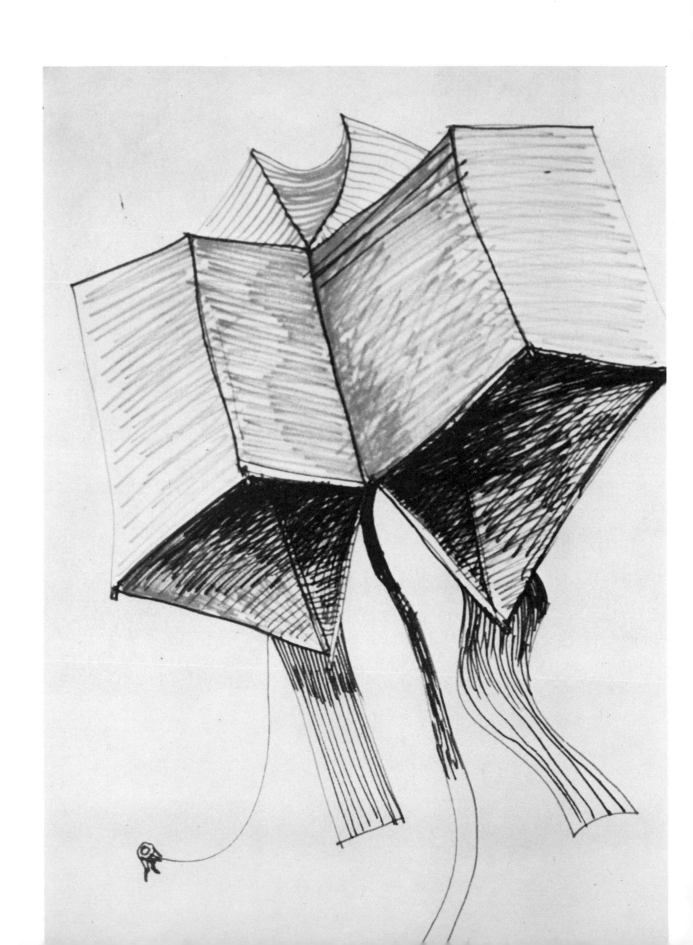

Unusual Viewpoints

Experiment with a variety of viewpoints. Sizes and placement of shapes give a feeling of space. The large kite form dominates the page and a small scaled figure appears to be distantly below.

Invention and Subject Themes

Once released, ideas tend to flow. Concentrating on a subject theme can allow the sketcher to broaden the concept by making variations of the subject as imaginatively as possible. Here is a sequence of explorations with numbers from a flat decorative application to several sculptural images.

By exploring your subconscious mind, you will dream up new and diverse solutions to artistic ideas. In these bird and people studies, we perceive playful ambiguities and irrational size relationships.

A word or national concern can generate a visual image. Experimenting with unique placements of lettering can suggest an imaginative approach to realizing an idea. Try one word sketches that produce strong images and force yourself to emphasize the unusual.

One way to get the inventive process going is to start with an image (a figure in a doorway for instance) and keep building a form or structure on top or around this initial idea. These two imaginative sketches have been progressively developed and embellished with line and pattern.

Exploring a Single Subject

Most people would agree that the more we concentrate or devote our energies to a single idea, the more likely we are to arrive at qualitatively superior results. The fact that our minds are capable of becoming thoroughly involved in whatever we pursue increases our chances for developing successful solutions. Writers, musicians, sports figures, and certainly artists use this concentrated effort to achieve satisfying accomplishments. Rembrandt spent innumerable hours sketching the beggars of Amsterdam; the Italian painter Morandi developed his whole artistic life from the fascinating arrangements of bottles in still lifes; Picasso exuberantly exploited minotaurs, bulls, and mythological characters in his sketches, etchings and paintings; and Cézanne gave us new insights on the landscape of France because he selected those aspects of his immediate environment that stimulated his creative powers. His studies of Mont Sainte-Victoire are world renowned.

For us, maybe more mundane subject matter might do the trick: the kitchen sink, slices of colorful fruit, a vegetable garden, old cars, family pets, people in the park, or the view of life from the back window.

Interest in subject matter is generated by personal intrigue or by taking time to look carefully at some captivating aspect of life. Repeatedly going back to look at something helps us to gain new insights and enthusiasm. Nibbling away at tough subjects by sketching generalities and interesting details can warm us up for a full sketching assault on any selected subject or theme.

As we have seen, subject selection can be made from innumerable possibilities. We will now concentrate on two ideas: on-site sketching of a single subject, and using our imaginative faculties to produce graphic ideas.

Two sites have been chosen as sketching locations. One is a harbor area where fishing boats assemble, and the other is an outdoor museum of old trains. Our imaginative exploration features figure themes.

Taking a subject through a metamorphosis can exploit a subject theme through stylistic changes or by adding a background. Graphic designer Carm Goode does a marvelous mood change with three versions of the same cat. By changing line qualities, value intensities, and textures, he creates a poignant interpretation of feline existence.

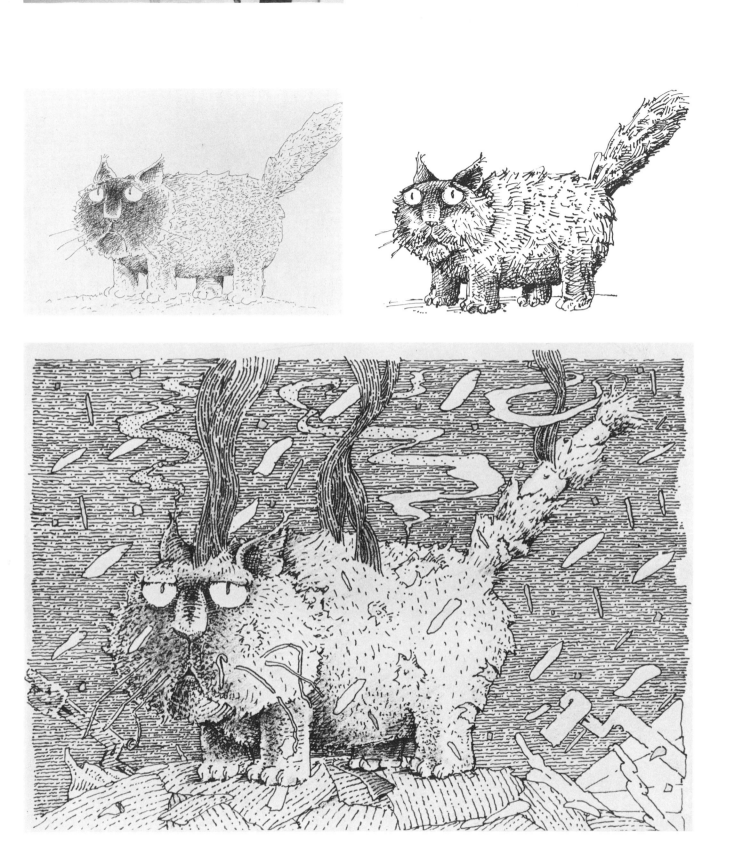

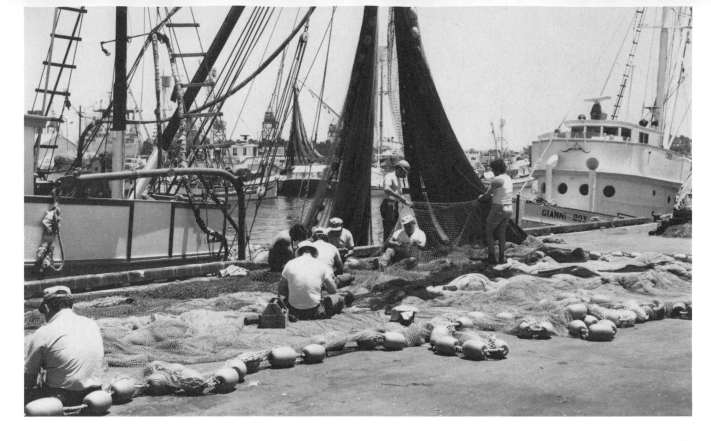

Sketching Boats

Upon arrival on a site, make a general survey of the location and try to sense its overall qualities. A brief walk to look at the subject possibilities can pinpoint sketching areas and focus our attention on the most promising viewpoints.

Once you have determined what you want to draw, begin at once. A few warm-up sketches will give you a feel for the subject. These can be very broad indications of boat shapes and their general structure. Concentrate on the basic forms and general proportions. Discern the structure and forget at this stage distracting details. Determine the shape of a boat's hull. Ascertain the placement of the superstructure in relation to the hull. Look for the placement and lengths of masts. Add to this analysis only those other items that seem significant to a general statement of that particular boat. These items may include side panels, hatches, winches and the main rigging. Drawing silhouettes of boats is an excellent way to get down to basic forms and the important shapes that describe the structure. Following this initial structural exploration, it is then profitable to start to dissect a boat's shape and to analyze its parts. Investigate front, rear, and three-quarter views, along with quick studies of the main details such as winches, rigging , crow's nests, anchors, and nets. Move around with your sketch pad to make informational sketches from many boats. Take in a variety of viewpoints—down shots, upward views, and cross sections. Following this preliminary work, it is desirable to reas-

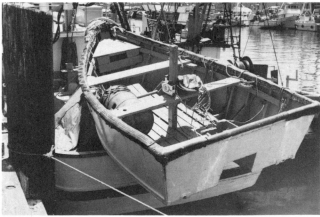

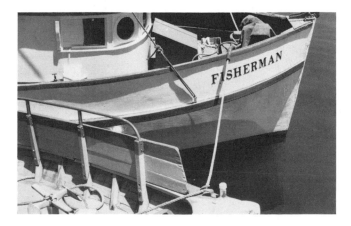

semble the total form, and to include adjacent environment such as other boats, water, and dock areas. Some sketches may be casually placed on your sketch pad; others should be consciously positioned to consider background and foreground areas, and how major shapes break up the page format.

After enough sketching has taken place, you will find some aspects of these boats that leave a strong impression. It may be their "form and function" appearance, their rugged power, or perhaps a design quality of opposing thrusts and angles. Whatever this quality may be, it is a clue for theme development. A sketch can become more of a message than mere description. Now aesthetic factors can be brought into the drawing process, such as line that fits the feelings you have about a form or structure, dark and light that conveys a feeling of power, and color (if used) to emphasize mood or lyrical qualities. At this time, whether on location or at home, you should separate yourself from slavish copying of your subject, and interject your own personal interpretative powers. All of your prior work can be informational and used as needed. You may want to compose freely, using boats as design forms to be arranged in whatever way satisfies your sensibilities. This is new ground to walk on, but undoubtedly it is the most challenging aspect of drawing. Your statements about boats can become very expressive graphic creations.

Once this full "experiencing" becomes part of your sketching procedure, you will sense a new challenge in every subject exploration process. Boats may happen to be of particular interest at a certain time. You may reacquaint yourself later with this same subject and try new versions, or you may go on to other subjects.

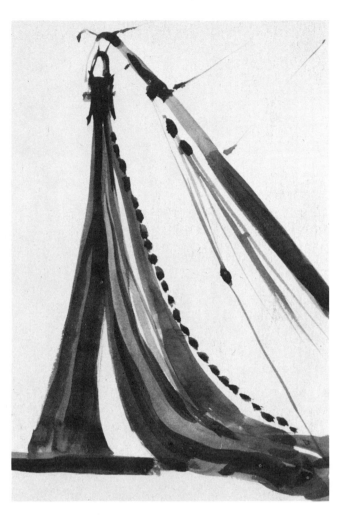

Using a dark wash of watercolor and a medium sized pointed brush, a quick mass study was made of a fishing net. Several darks have been added to the initial wash to accent the main masses and some details.

Sketchbook drawings of very rapid impressions of boat forms are an ideal way to warm up to a subject.

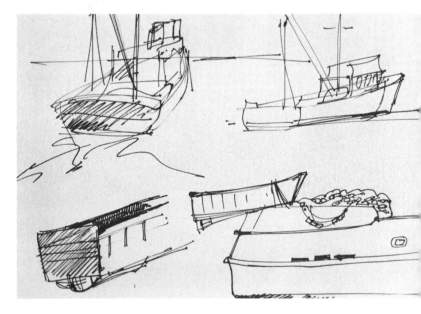

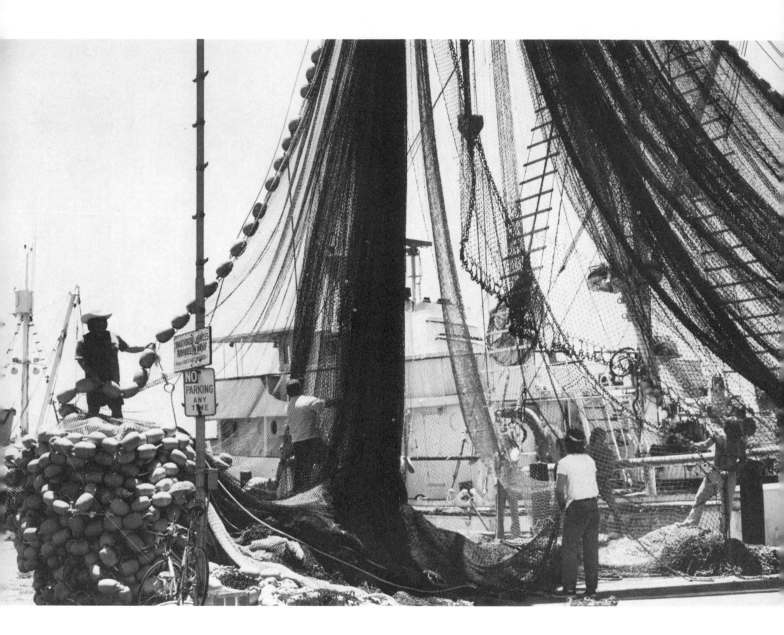

Sketching Details

Net handling is fascinating to watch and provides a good opportunity to sketch figures in action. Simple studies done with a felt pen can be made in short time spans. Try for the action with a minimum of supporting detail. Sketches like this provide excellent material for later drawings.

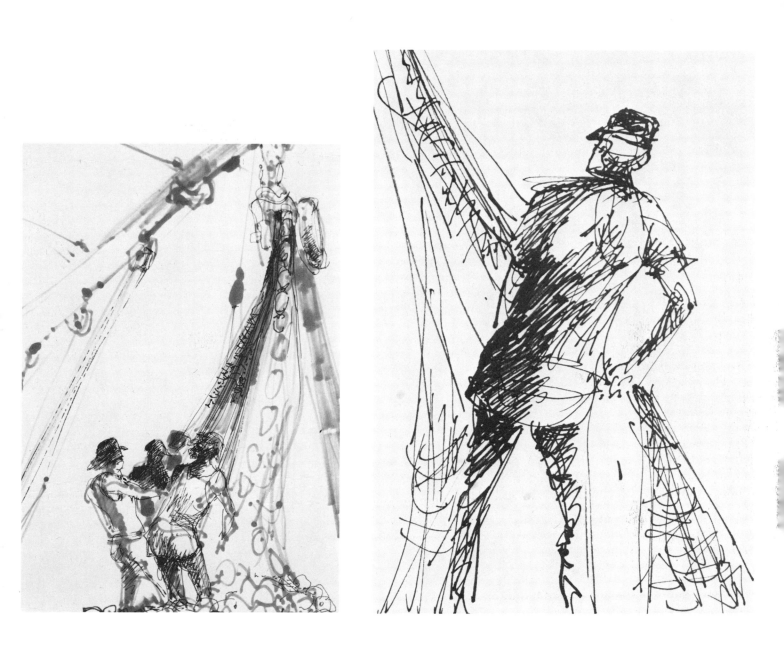

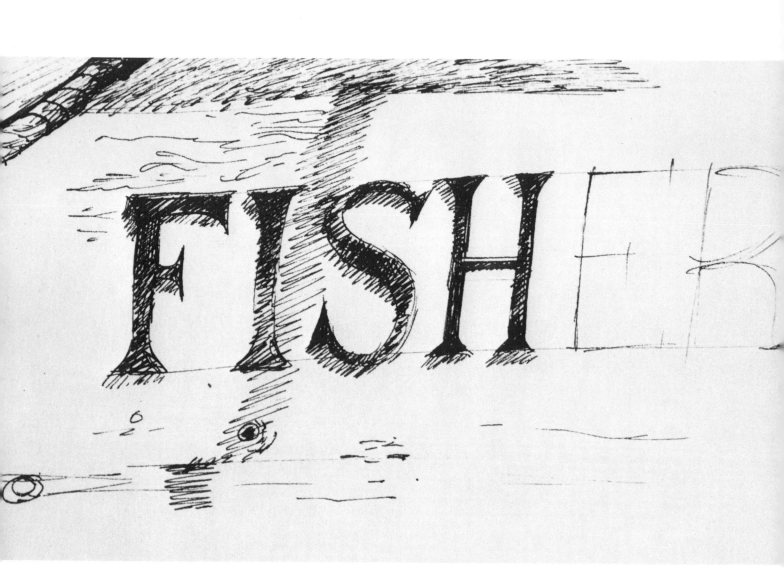

An informational study of boat lettering looks at raised letter forms, an adjacent piece of rope, and a cast shadow.

An exploration of space with the use of darks can be used along with a structural analysis of a crow's nest. Areas can be pushed back or inward with value build-ups.

An analytical line study of a fishing skiff stresses the structure of this boat. Establishing the main shapes with thin skeletal guidelines helps to conceive the total form. This more involved type of sketch is done for information.

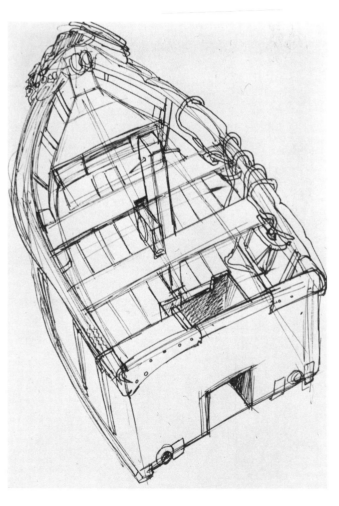

Watercolor Studies

Watercolor is a versatile medium for executing either quick studies or doing more involved paintings. For sketching purposes, a small portable color box is a desirable addition to drawing media. Two or three brushes enable one to move from broad general shapes to those finalizing small details. As we see in this step-by-step series, a study is built in successive stages. The initial step establishes the composition, states the main forms, and suggests sky and water areas. In the second stage, forms are more clearly defined and supporting silhouettes are developed in background areas. In the last two steps, the final darks and details are inserted, including vertical sky washes to break up the upper area and to carry an extended thrust from the boat shapes.

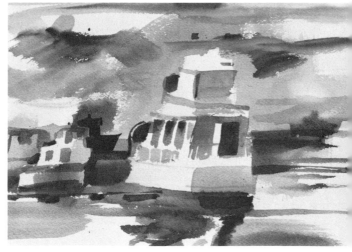

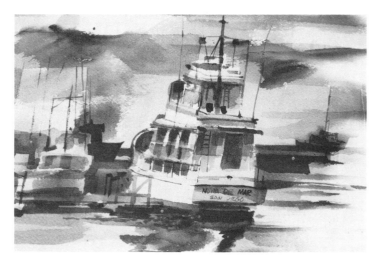

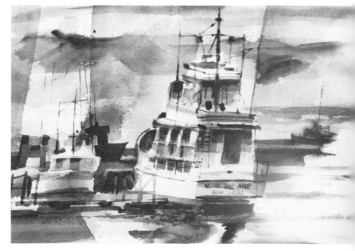

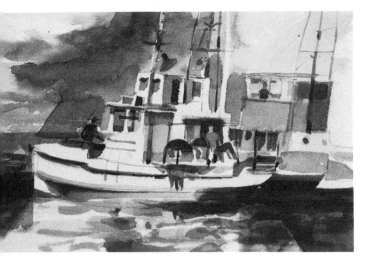

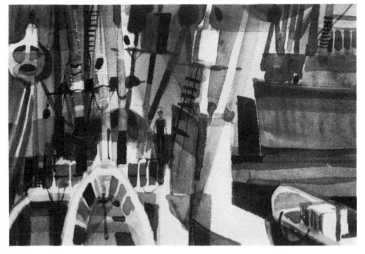

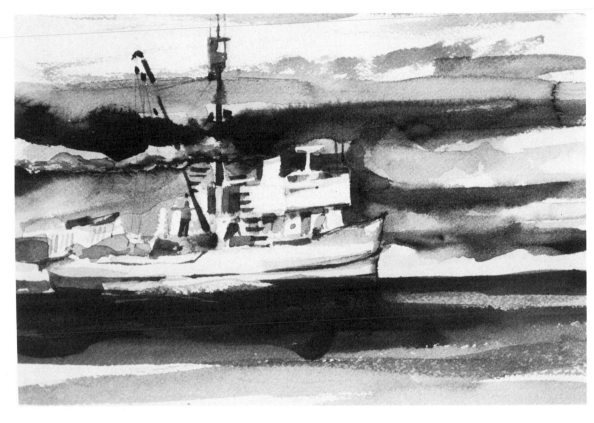

These studies were done on location. In each case improvised backgrounds and figure insertions helped to individualize each statement. Contrasting water and sky areas are important elements in forcing attention to the boat forms. The introduction of more mast shapes and rigging in the sectional view, plus improvised background shapes, was a radical departure from the viewable subject matter.

Trains as Subject Matter Themes

A museum of old trains in Griffith Park, Los Angeles, California, has been a fascinating sketching site for art students for many years. Although these locomotives are well past their prime, they possess a powerful dignity, and reflect a bygone era of transportation and railroad life that still carries an impact today. These trains are tough to draw. Their complex structure and myriad forms will make you quail a bit when you first open your sketchbook. But intriguing subjects like these are worthy of those of you who want to increase your sketching prowess. Furthermore, the prospects of using such subject matter for inventive purposes are unique. All kinds of visual images can come into imaginative play—trains in motion, trains at night, trains bedecked with bunting and flags, trains in a landscape, trains that are racing or nearing collision. The possibilities are endless.

Once again, acquaint yourself with the subject matter by studying general views and overall impressions. Perhaps jot down your feelings in words. Take a good look at major shapes and parts. What makes this locomotive work as a total unit? The wheels, levers, and connecting shafts all play a role in stating the operational power of an engine. These parts should be drawn until a familiarity develops with how parts fit and relate to one another. A concern with scale is important. The size and relationship of an engine's parts should be exaggerated to suggest its impressive weight and power. Compare wheel size with boiler height and length. Check the cab's dimensions against the overall dimensions. Avoid drawing oversized windows, lettering, or small details. Tend to reduce small items and expand the large forms. Think also of the total form of the engine—its front, sides, rear, wheels, and supporting tracks. Sense the train's weight pressing downward against the rails.

Studies in wash or black and white drawings of major considerations help the artist to deal with the visual impact of major forms. These efforts can be realized as silhouettes or line and mass sketches. The simple silhouette of a shape, such as a smokestack or cab, can state basic shapes quickly. Such forms can be developed later in more complex ways with line and value added to enhance the underlying form. Watercolor washes and ink line are excellent media for quick studies of train shapes. These studies can be done on heavier paper in a sketchbook, on individual watercolor sheets, or on a watercolor block. When using a brush and a fairly dark wash of color, such as a brown or blue, you can expeditiously note shapes and details in mass forms that convey general impressions. Details can also be treated in both mass and line. Mass areas denote the solid aspects of form whereas line works well to depict thin shapes such as spokes, steam lines, or railings.

A number of on-site sketching sessions are needed to establish a satisfactory group of visual notes. Armed with these sessions and some fresh memories, it is then exciting to evolve your own ideas or to pursue a particular direction or theme. You may want to start placing trains in different environments, to add figures in conjunction with trains, or to make design statements with sections of trains. Once a theme jells in your mind, you can be off and running until your exploration seems fulfilled. This type of on-site investigation and imaginative follow-through will greatly expand both drawing and creative growth. After all, the purpose of sketching is to expand our perceptive and imaginative powers so that visual statements will have conviction and quality. Sketching sharpens our eye, enlarges our visual memory file, and opens up the channels for new artistic opportunities.

A student sketcher tackles the intriguing subject matter of old steam locomotives at an outdoor train museum.

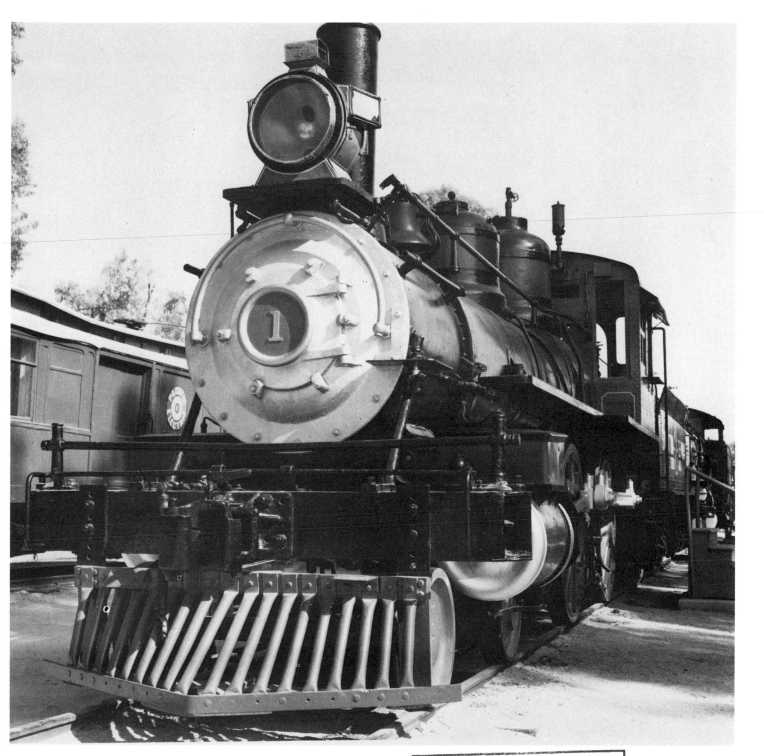

111

Sketching Details

Studying the structure of sections of trains helps us to understand both the basic forms and the unique character of particular segments. Wheel details may vary from engine to engine but the essential form remains consistent.

Studies should be made of single wheel elements and wheel groups. Quick informational studies develop confidence in drawing complex mechanisms as well as providing a good visual reference file.

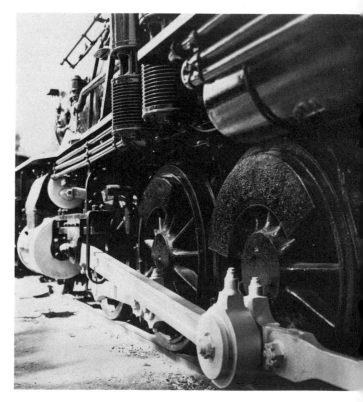

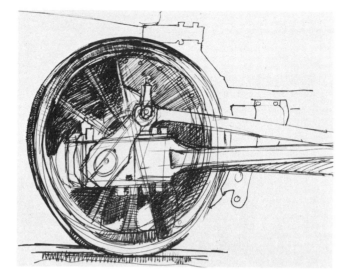

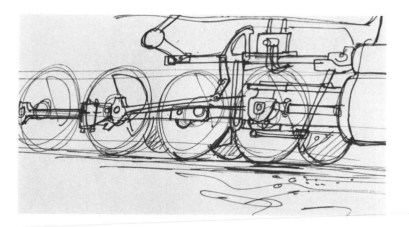

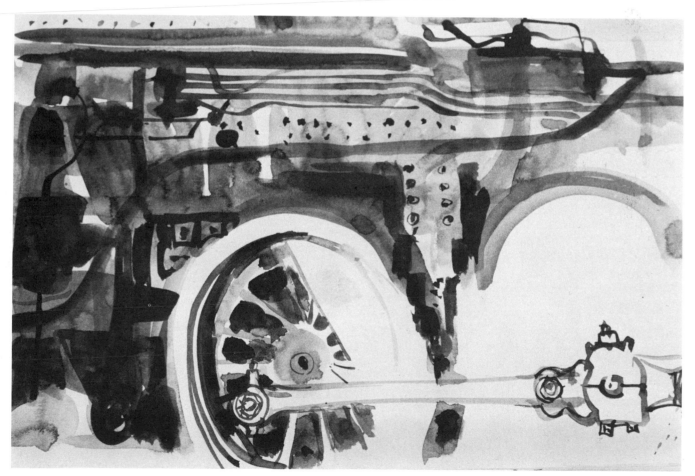

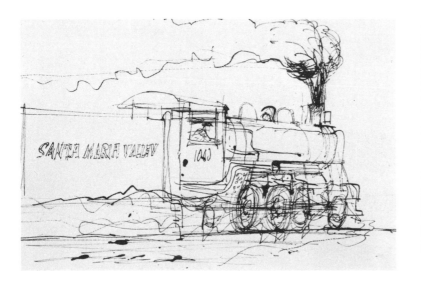

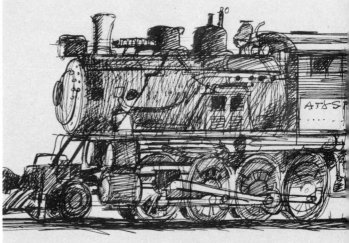

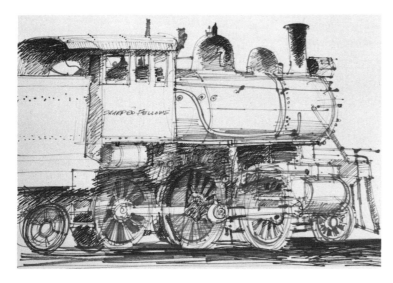

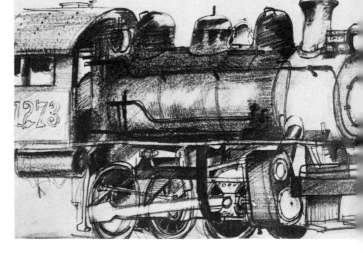

Engines as Subject Matter Themes

Drawing an engine should start with light structural lines to delineate the larger forms and scale major elements. These four drawings represent a variety of graphic solutions from a quick gestural line study *(upper left)* to a rendered study in pencil *(lower right).*

114

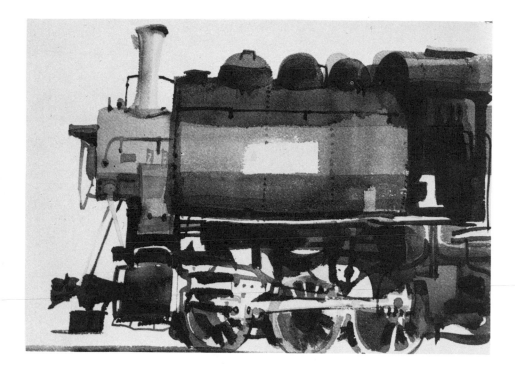

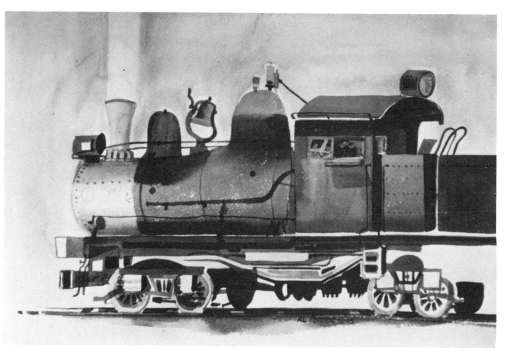

Whether working with dark washes *(above)* or in full watercolor *(below)*, the approach can be the same—to paint the larger forms first in a general light value. White paper can be left to read as white shapes. Over the first dried wash deeper values are added successively to build solidity and render forms. Final darks should complete the statement with lineal details and silhouetted shapes.

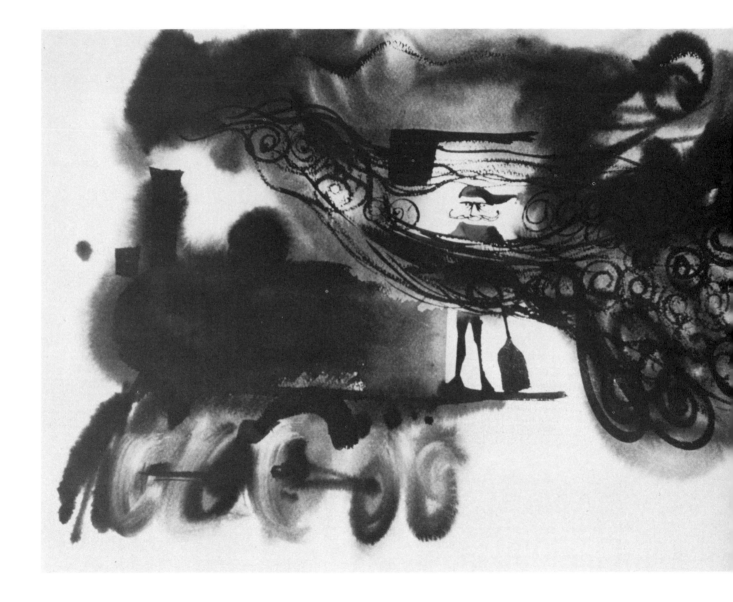

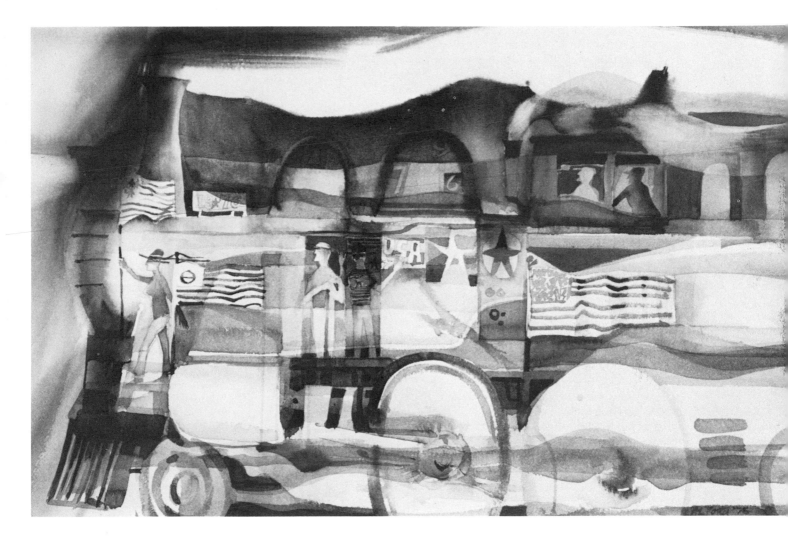

From the drawing experience, the creative follow-up evolves
naturally. These two paintings represent the free interpretative
exploration of engine forms as subject matter. The Santa Claus
engineer looks through stylized smoke produced by wet water-
color washes and dry line overlays. *A Time for Flags* uses a
designed train form with figure and flag additives to express the
1976 Bicentennial theme.

Working from Our Imagination

The greatest repository of ideas is in our heads. The artist or art-oriented person tends to use his sensory organs (eyes and ears principally) continually to soak up impressions about life and subjects that he sees as significant. This bank of ideas can be drawn on whenever needed; when this account is fortified with strong art skills, the outflow of responses can be continuous.

Learning to work this memory bank in a creative way is the biggest and most important challenge. Being confident, you can tackle themes or subject matter with enthusiasm, and find that sketching ability pays off in fruitful production. Again, it is well to remind yourself that this kind of sketching trades accuracy and detailed information for expressiveness. You may miss on the details but strike rich on creative solutions. You can now draw more intuitively and spontaneously, and occasionally recklessly. No longer bound by subject matter in front of you, you can generate better answers to the imaginative positioning of forms, make arbitrary use of color and value, and be freer with the use of line for descriptive purposes or design qualities. Although at first you may feel wobbly in tackling a piece of white paper without your usual visual crutches, once you get seriously involved (that means numerous efforts), the creative juices flow, and you learn to trust both your memory and imaginative capacities.

Themes may be quite simple. You may just repeat a single subject idea in different fashions. Three or four drawings of a single head can be done in various states from a fully rendered to a simplified line study. You may want to take off on your favorite activity, such as a sporting skill. You may have a yen for yesteryear and therefore do some nostaligic sketches of historical figures or places. Or perhaps just working with abstract shapes and patterns can do the trick (our phone pads reflect this type of improvised doodling).

Most important of all, is to incorporate this sense of imaginative play when sketching from life. Interject your own unique way or style, and change arbitrarily any part of your drawing that you feel could be improved by a more imaginative approach.

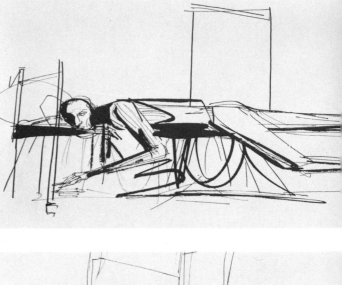

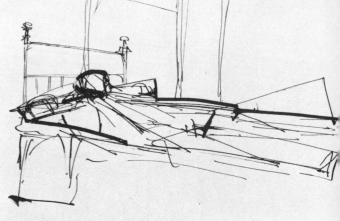

118

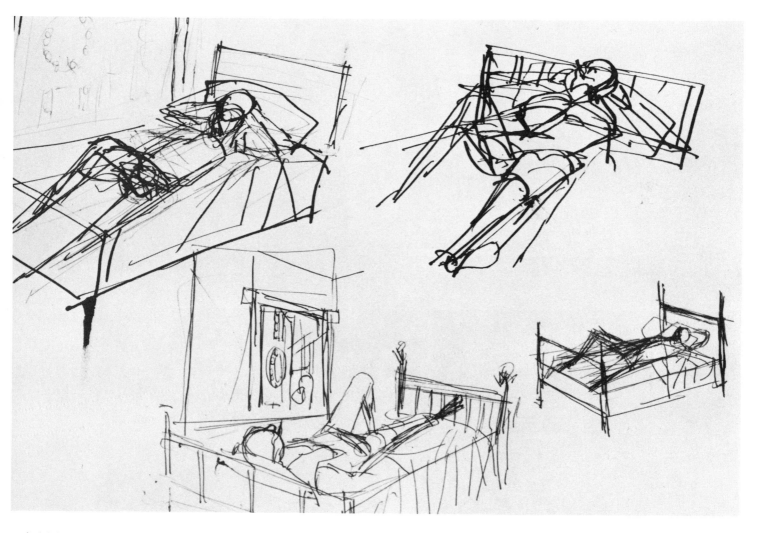

Artist Joe Mugnaini's sketchbooks are filled with visual ideas he uses for etchings and paintings. His studies of a man on a bed explore a variety of figure placements which help him to arrive at the most appropriate form for an illustrative assignment.

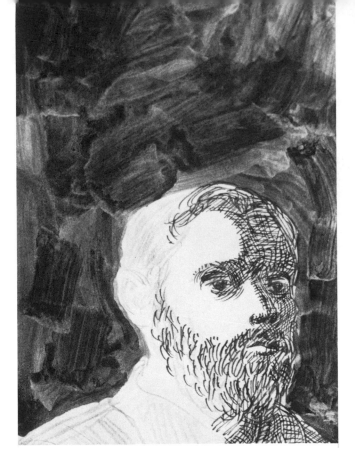

How you position a form **on a page**, use line and value to strengthen it, reflects your creative capacities to compose your ideas. Sam Clayberger's sketchbooks overflow with such innovative drawings. This sampling imaginatively investigates hair styles as well as head placements within a format.

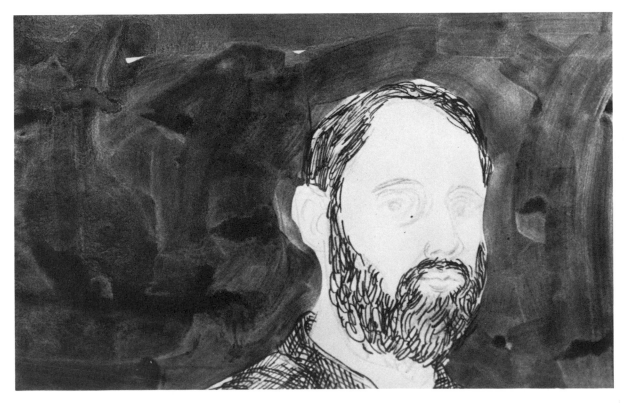

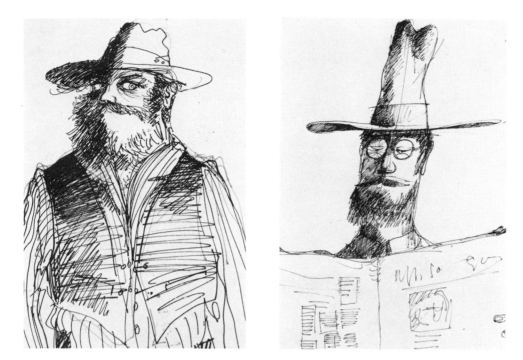

The possibilities of sketching imaginative cowboys are endless.
Quick studies such as these capture the expressive character of
the wild west with a touch of humor. Television and old western
movies can be excellent motivators to actuate our imagination.

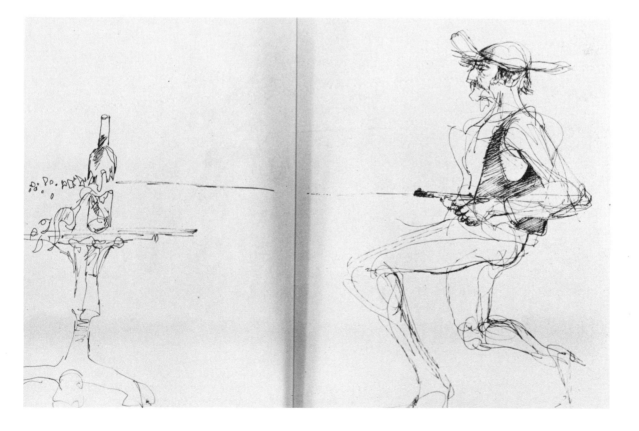

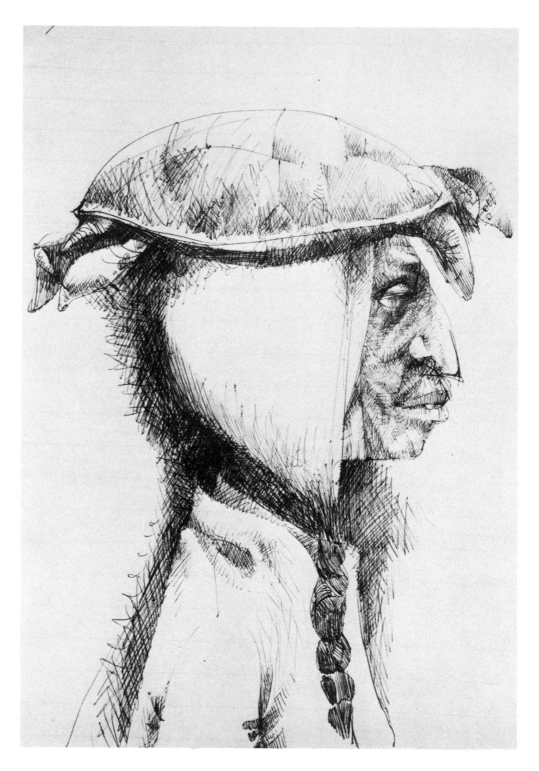

Bill Pajaud loves both fishing and sketching. These two activities often come together, resulting in numerous drawings and water-colors of one of his favorite themes—fishermen and sea life. Here, we see turtle drawings on lined note pad paper.

In Summary

Summing up, the exploration of a subject requires several important aspects of involvement. These steps include: (1) the selection of material we find sufficiently interesting and worthy of exploration; (2) concentrated looking at both major forms and details to discern important qualities; (3) various sketching approaches to familiarize ourselves with the subject; (4) enough time involvement to ensure sketching competency; and (5) putting together through impressions and sketches a number of completed works that capture the essential qualities of the subject.

Exploration should be part of every artist's search for creative identity. Sketching themes or concentrating on a single subject guarantees more significant results.

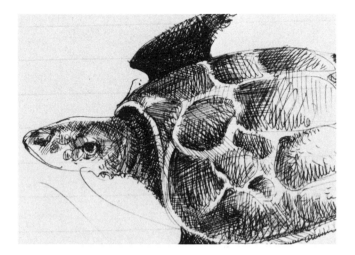

Using Sketches–Five Artists' Work

This final chapter focuses on the work of five artists. Here, we shall confirm the concept that a vast amount of creative work comes out of the fluid ideas expressed through sketches.

These artists are consummate sketchers who handle the exploration of ideas with relative ease. They use their sketches to generate new forms of expression and to aid them in realizing their dominant goal—the creation of important visual statements that deliver a message or that reflect the significant aesthetic qualities in life.

Furthermore, such artists are constantly searching for new ideas in a variety of media. Perhaps the one underlying, basic approach to both the search and seizure of ideas is the use of sketches to capture their thoughts, feelings, and interpretations.

Sketches for Etchings

Joe Mugnaini, well known for his expertise in drawing and painting, finds printmaking an expressive force for delivering his visual ideas. Etching requires strong imagery, and his sketches probe the unique and unknown with powerful line and value. Quick compositions, similar to this sketch, are often translated into evocative etchings.

Etching entitled "Baroque," 11" x 17", by Joe Mugnaini. Sketches on opposite page are for the book *Martian Chronicles* by Ray Bradbury.

chapter heading — august 2002
MARTIAN CHRONICLES.

no green
rd wh bl only

Sketches from Environmental Influences

Whether he is sketching the Berlin Wall in Germany or the city hall in Greenville, North Carolina, Ed Reep elicits strong graphic response. From quick studies of border guards and the Brandenburg Gate in Berlin to a finished drawing of a memorial wreath near the dividing wall, Reep's work states the vital information with conviction and sensitivity. His Greenville series of paintings were first explored with numerous preliminaries like these two sketch sheets.

Using Sketches for the Transformation of Ideas

Don Lagerberg generates a host of ideas for a painting series through line studies of the images he intends to transform into paint. His studio walls are often covered with small sketches that manipulate numerous visual thoughts. These shorthand notes are enlarged into precisely considered pattern sheets that fit the final painting's format.

These two sketches explore a solitary figure within a confined space. Grid patterns are often employed for enlarging a sketch onto the final working surface.

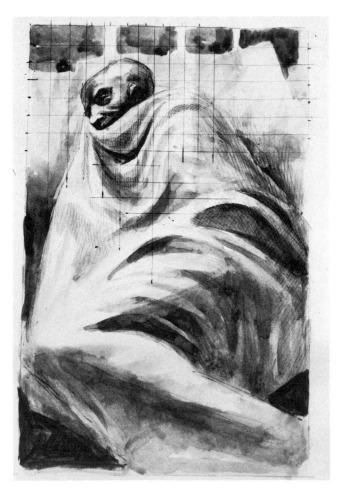

Using Sketches for Sculpture

Charles White's drawing technique features a strong three-dimensional quality produced by overlaid lines and massed darks. A natural outgrowth from his finished drawings is ideas for sculptural pieces. A page of sketches shows experiments with whimsical shapes and patterns while a single sketch considers the possibilities of a head study to be sculpted in stone.

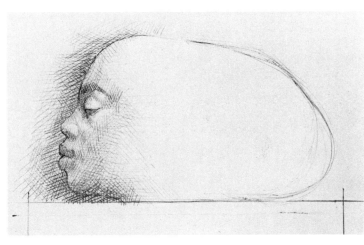

Handwritten notes (top of page):

Lid: Lightning bolt handle?

4 Jan 75

SERVER: Clouds — Ag[?]
Handle: Rainbow — wood
Spout: End of rainbow — shakudo brass
cups: pots of gold — Cu w/ augilt inside or all au gilt

Embellishment: Cu birds

(handwritten, lower left): or gold gilt! au rim

TOP VIEW

Sketches and the Crafts

Artist-craftsman Al Ching uses his sketching facility to visualize both the final product, an exquisite teapot entitled *Cloud Server,* and the necessary details. We see here a sequence from initial ideas to a careful rendering. Templates of cardboard, used to measure metal pieces, evolved from sketch ideas. The final fabricated showpiece represents hours of crafted skill.

132

Conclusion

This book germinated some time ago from a growing concern for developing and sustaining drawing skills. So often the shortcuts to artistic expression bypassed the important function of drawing and, in particular, sketching—that wonderful freely exploring visual process that investigates ideas and generates solutions.

Through my association with artists and students of art, I have become reassured that this lively art is not dead, but is vitally active for the productive person, and only dormant for others. To awaken this potential group, this book and others like it are sincerely dedicated. Once awakened, the student of graphic expression will start to find his full potential.

The sketching process will not only sharpen his drawing ability, but will enlarge his range of imaginative ideas considerably. Once the sketching habit takes hold, a newer, stimulating visual force will be put into action. Constant sketching fulfills a creative expressive need, ensures confidence, and provokes a daring to engage in a world of challenging ideas.

Sketching is part of a rich heritage that has flourished for centuries. The sketchbooks of Rembrandt, Leonardo Da Vinci, Goya, Picasso, Matisse, Homer, and others, have given us a legacy of exciting visual responses to the external world. Our world is equally stimulating, and the open sketchbook is a challenge to capture a slice of it.

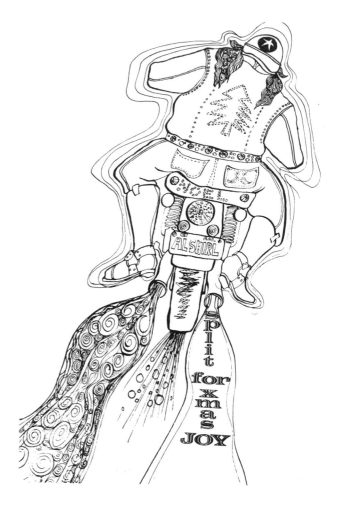

Index

Sketch by Sam Clayberger

Acknowledgments

I am deeply indebted to many people for their time, energies, and creative work. The following artists have made the art of sketching an integral part of their productive lives, and were extremely generous in sharing their work and ideas: Gerald Brommer, Al Ching, Sam Clayberger, Joe Gatto, Carm Goode, Don Lagerberg, Kay Lew, Joe Mugnaini, Bill Pajaud, Ed Reep, Marv Rubin, Elin Waite, Charles White, Kim Williams, Jane Wood, and Robert E. Wood.

Added to this distinguished group are the inspirations of many students on both the high school and university level. Tom Holste, Art professor at California State University, Fullerton, gave valuable help with student work.

In particular, I would like to thank Kevin Burton, Ron Battle and Charles Paige for exciting sketchbook work.

Frank's Photo Lab in North Hollywood, California, assisted superbly with photographic printing and enlargements. The Orlando Gallery of Encino, California, was most generous in allowing the works of Don Lagerberg to be reproduced in this book.

To my wife Shirl, my appreciation for positive and continuous reinforcement.